IMAGES
of America
COLMA

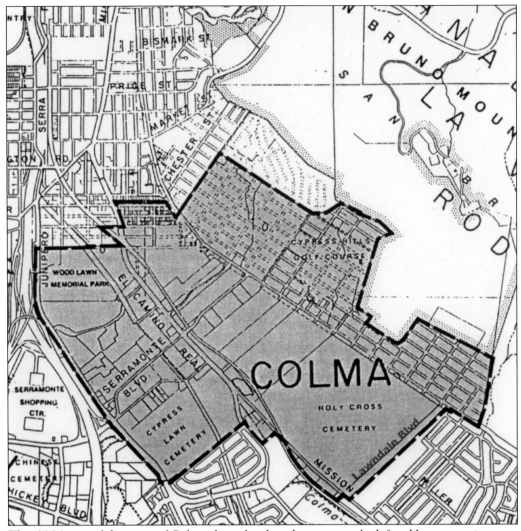

This 2006 map of the town of Colma shows borders that are mostly defined by cemeteries.

IMAGES
of America

COLMA

Michael Smookler

ARCADIA
PUBLISHING

Published by Arcadia Publishing
Charleston SC, Chicago IL, Portsmouth NH, San Francisco CA

Printed in the United States of America

Library of Congress Catalog Card Number: 2006938517

For all general information contact Arcadia Publishing at:
Telephone 843-853-2070
Fax 843-853-0044
E-mail sales@arcadiapublishing.com
For customer service and orders:
Toll-Free 1-888-313-2665

Visit us on the Internet at www.arcadiapublishing.com

CONTENTS

ACKNOWLEDGMENTS

My right-hand man for this project was Lee Marsigli. Lee has lived in Colma for almost 60 years, and his uncle Giuseppe settled in Colma in 1907. Lee opened many doors for me to interview individuals, including Shirley Michelletti, Al Capurro, George Ginilo, Blandin Molloy, Andrew Canepa, Esther Ottonello Castagnetto, Kathy Atkinson, Steve Doukas, Violet Chelone, Judy Edmonson, retired fire chief George Riccomi, Joe Deng, Pat Hatfield and the Colma Historical Association, Colma police chief Bob Lotti, Louis Bacigulupi, and Karen Selmi. Others who contributed were Helen Callan Carey, Mike Guisti, Steve Salacci, Richard Rocchetta, Nick of Lefty O'Doul's Restaurant in San Francisco, Jack Olsen, and Marylin Olcese.

INTRODUCTION

When people are asked what they know about Colma, most respond, "Oh, you mean the City of the Dead." They say this because there are 17 cemeteries within its limits. These cemeteries make up 73 percent of a city only 2.25 square miles in size. It almost goes without saying that the official slogan is "it's great to be alive in Colma." There are over 1.5 million people buried and 1,500 living people in the city. But there has been and there is more to Colma than cemeteries. Colma has a rich farming and transportation history and, along with its cemeteries, makes for a fascinating story of a unique American community.

For the first 60 years of Colma's existence, it was composed of all the land south of the San Francisco's southern boundary to Baden (currently known as the city of South San Francisco) and west of the ridge of San Bruno Mountain to the Pacific Ocean. In 1911, most of this land, along with the Colma's business district, was incorporated as Daly City. By the time Colma incorporated in 1924, it was close to its present size. It is in San Mateo County.

Colma—the area and the town—have been geographically at a crossroads on the San Francisco Peninsula since the early 1850s. Colma has been a notable stop between peninsula cities as a center for agriculture and industry, as well as being home to various ethnic groups. Reached first by wagons, then by the railroad, followed by automobiles and now rapid transit, this often cold, damp, foggy, drizzly place has a distinct character of its own. Cemeteries are not everything in Colma, but the town of Colma would never have existed without them.

Colma News.

Advertise In The NEWS.

Subscribe For The NEWS.

No. 4, Vol. 1. COLMA, CAL. APRIL 14, 1894. PRICE 5 CENTS.

COLMA.

" The village of Colma is a quiet little settlement about five miles south of San Francisco. It nestles in between the hills that skirt the ocean on the west and the bay range, known as the San Bruno mountains, on the east.

" A prettier place could not have been found for a growing village. During the summer it has none of the sweltering heat so often experienced by the interior towns of this state; being between the waters of the bay and ocean the temperature is kept cool.

" Considerable business is transacted by the local residents.

There are groceries; butchers; barbers; shoemakers; telegraph office; express office; saloons; a local comedy troupe and good schools. There is a newspaper published here, devoted exclusively to the interests of the place and people.

" Bonds are now issued to the amount of $15,000 wherewith to purchase a site and build a new school house. Surely, we are not neglecting educational facilities.

" Last month, there was shipped from here directly to eastern markets 1,742,825 pounds of cabbage; the largest industry here, and carried on by the Italians.

" An electric railroad connects Colma with San Francisco; which is but twenty minutes ride.

" Altogether, we are satisfied with our lot, and will extend a willing hand to any and all who should choose to settle among us.

"Did you say you wanted the NEWS for six months?"
"Yes sir; please."

This is the front page of the *Colma News*, dated April 14, 1894, with C. F. Merrill as editor and proprietor. The left-hand column gives a quaint description of Colma in 1894. (Courtesy of the estate of Emma Ver-Linden.)

One

EARLY SETTLERS AND FARMERS
1853–1924

The origin of the name "Colma" is uncertain. Most likely it came from immigrants who had prospected for gold in the early 1850s near the towns of Colusa or Coloma in the Sierra foothills of California. Some of these prospectors later settled in Colma, where they began farms raising crops, livestock, and flowers.

The nomadic Ohlone Indians first inhabited Colma. The arrival of Spanish explorers in the 18th century spelled the decline of the native population. In 1821, the future Colma became part of the Mexican land grant known as Rancho Buri Buri. Thirty years later, after California attained statehood, Colma opened for homesteaders.

Rich, sandy soil and excellent natural drainage made Colma a fertile and desirable place for farming. Over the last 150 years, Colma has been settled by Irish immigrants who grew potatoes from the 1850s to 1877, followed by Italians who grew vegetables and flowers and raised livestock, to, in recent years, Filipinos doing the same. Through it all, Colma has maintained its small size.

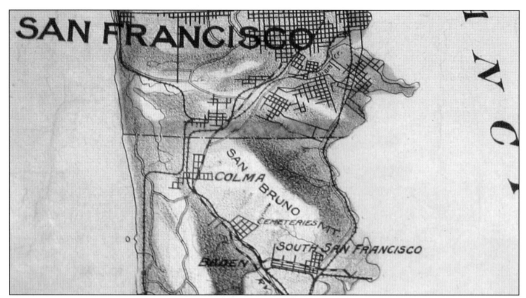

The unincorporated area of Colma is seen here in this section from a larger map printed in 1907. Colma is just below the southern border of the city of San Francisco. (Courtesy of the Colma Historical Association.)

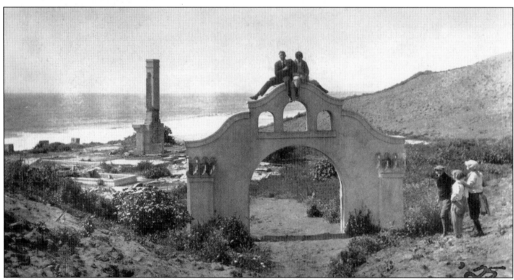

The ruins of Robert S. Thornton's beach house could still be seen and visited in 1925. They were later located within Thornton Beach State Park, and were buried by thousands of tons of sand washed down from the slopes above them in 1982 and 1983. Thornton settled in Colma in the early 1850s. He was one of many Irish immigrants and farmers who grew potatoes and grain. He represented his fellow homesteaders in their fight for their land rights against corrupt land-grabbers all the way to the U.S. Supreme Court. He died in 1917 at the age of 100. (Courtesy of the estate of Emma Ver-Linden.)

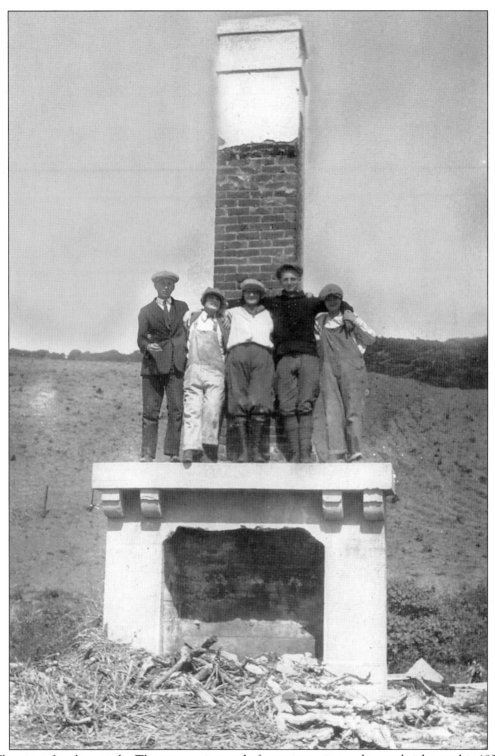

The giant fireplace at the Thornton ruins made for an imposing and surreal sight, as this 1925 image shows. (Courtesy of the estate of Emma Ver-Linden.)

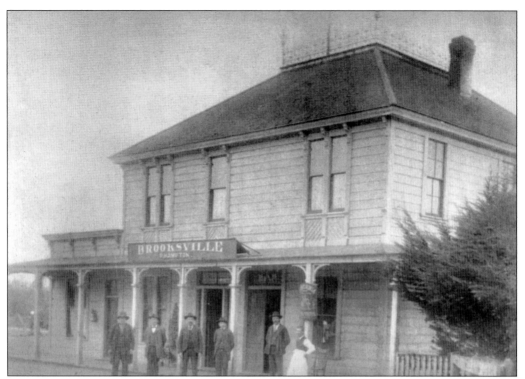

One of the early establishments in Colma, the Brooksville Hotel was formerly known as the Brooks and Carey Saloon. Built in 1883 on Mission Road, it was sold to Frank Molloy in 1929 and renamed Molloy's. (Courtesy of Lanty Molloy.)

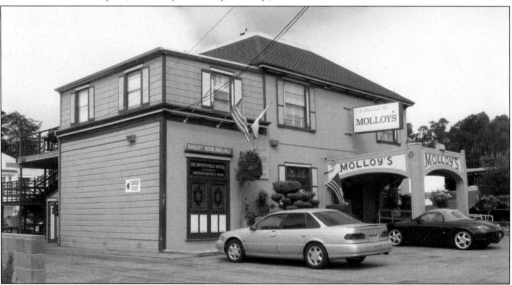

Molloy's looks a little different in 2006 but is still recognizable. Frank remodeled the inside and added stucco to two exterior walls. No longer a hotel today, it is now a popular Irish pub operated by Frank's son Lanty, Lanty's wife, Blandin, and their son Owen. The establishment is closed three days a year, Christmas, Thanksgiving, and Easter, and is open from 9:30 a.m. to 1:00 a.m. (Courtesy of the author.)

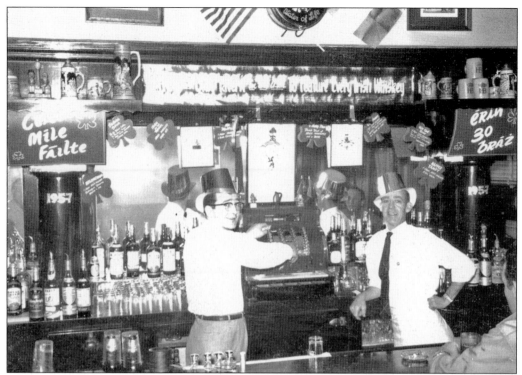

Lanty Molloy and his friend Tom Maguire tend the bar on St. Patrick's Day in 1957. There have been many Irish wakes and parties held at Molloy's. (Courtesy of Blandin Molloy.)

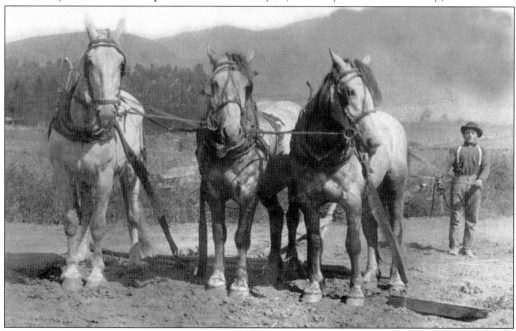

Berto Schenoni, who arrived from Genoa, Italy, 1890, is pictured here with his horses in 1898. His grandson, Al Capurro, farmed in Colma until 1955. Berto lived to be 100 years old. (Courtesy of Al Capurro.)

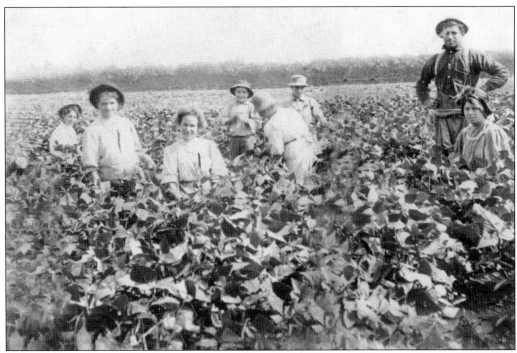

Field hands pose amid the crops on the Schenoni Ranch in 1920. (Courtesy of Al Capurro.)

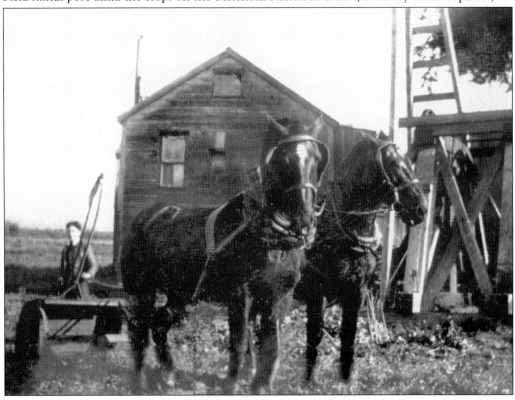

Al Capurro is pictured here with a team of horses in 1931. (Courtesy of Al Capurro.)

The Schenoni Ranch, seen here in 1939, was located on the west side of San Bruno Mountain. (Courtesy of Al Capurro.)

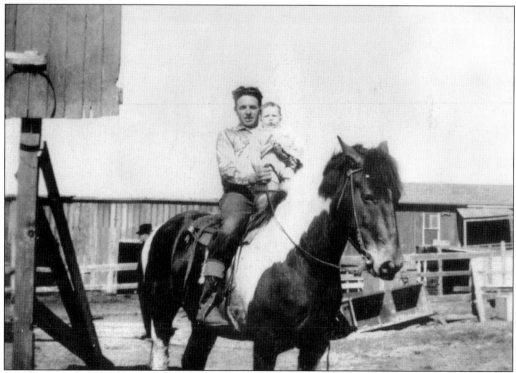

Al Capurro holds his son on a horse in 1940. As of this writing (2006), Al Capurro is 90 years old and lives in his house in neighboring Daly City. (Courtesy of Al Capurro.)

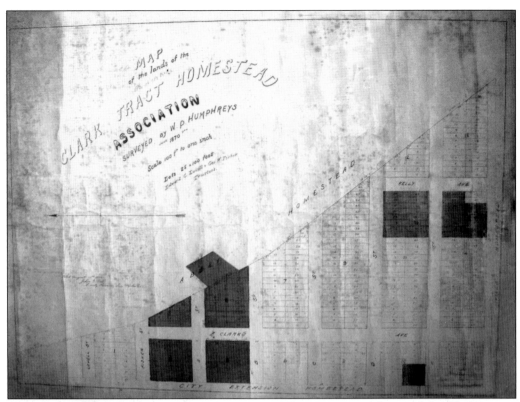

This is an original map of the Clark Tract Homestead in Colma, which was surveyed in 1870. The dark, shaded areas indicate properties owned by the Rosaia family who were early Colma farmers. This land is located today in the Sterling Park development in the area of A to F Streets. (Courtesy of Shirley Michelletti.)

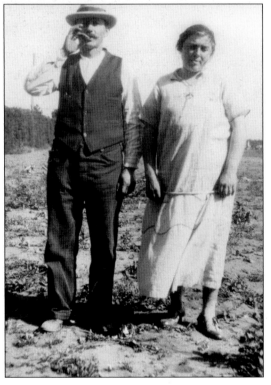

Adelino and Ermina Rosaia are pictured here at their ranch in 1929. Adelino was born in Spain. (Courtesy of Shirley Michelletti.)

Born in Italy, Leno (left), Ezio (center), and Ernest Rosaia, the sons of Adelino and Ermina, pose here in 1929. (Courtesy of Shirley Michelletti.)

These are the Rosaia's stables and their house, on the right, in 1949. When Adelino passed away that year, so too did the Rosaia Ranch. (Courtesy of Shirley Michelletti.)

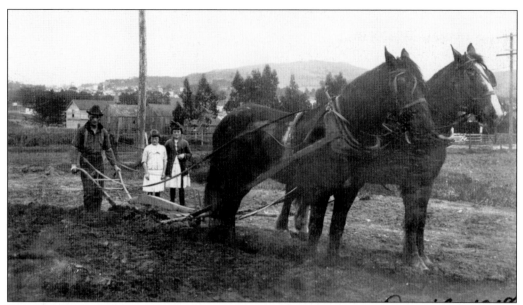

Sisters Sybil and Emma Ver-Linden are pictured here, in the background, in April 1918. The Ver-Linden family settled in Colma in the early 1890s. (Courtesy of the estate of Emma Ver-Linden.)

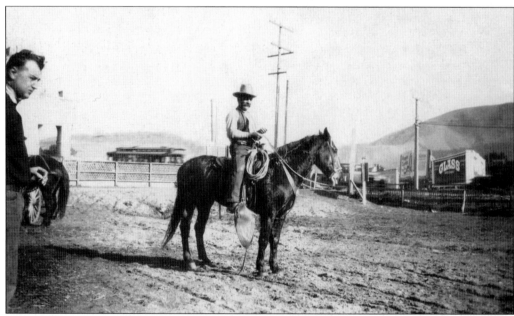

The Ver-Linden property was located south of A Street near Millet's Court. To the left and behind the man on the horse is a streetcar. (Courtesy of the estate of Emma Ver-Linden.)

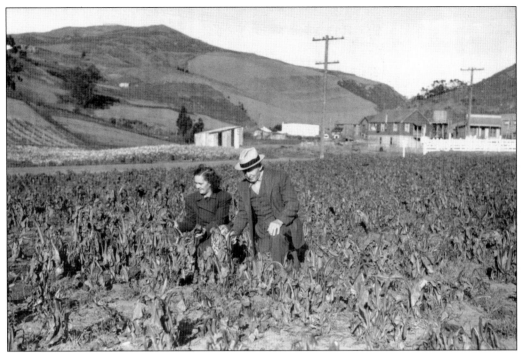

Mae and Albert Witt are kneeling here in their field of frozen camellias on January 9, 1949. The Witts operated a Colma dairy and raised flowers. (Courtesy of the estate of Emma Ver-Linden.)

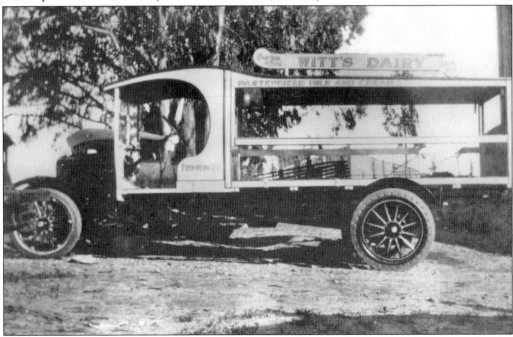

This is a 1914 Witt Dairy delivery truck. Begun in 1888, the Witt Dairy delivered milk to San Francisco, even during the 1906 earthquake. Other Colma dairies included Valley Dairy, which advertised "non-reacting tuberculin tested cows," and the Olympic Farms Dairy Company. (Courtesy of the Colma Historical Association.)

Theodore Cerruti Sr. stands on the running board of his vegetable truck in 1921. Emigrating from Genoa, Italy, in 1920, Cerruti Sr. operated a vegetable farm in Colma. When asked what they grew, Theodore's son Ted said that the farm was like a drugstore—they grew a little of everything. The Cerruti farm was the last one to leave Colma in 1971. Ted moved the farm to neighboring South San Francisco in the Orange Park District, where, in 2006, he is a wholesale vegetable grower. (Courtesy of Ted Cerruti and Company.)

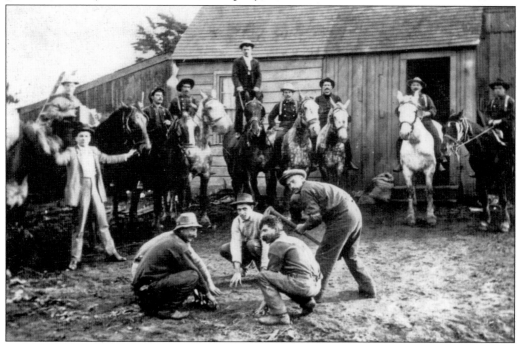

Colma farmhands, like most working folk, enjoyed a little leisure from time to time. (Courtesy of the History Guild of Daly City/Colma.)

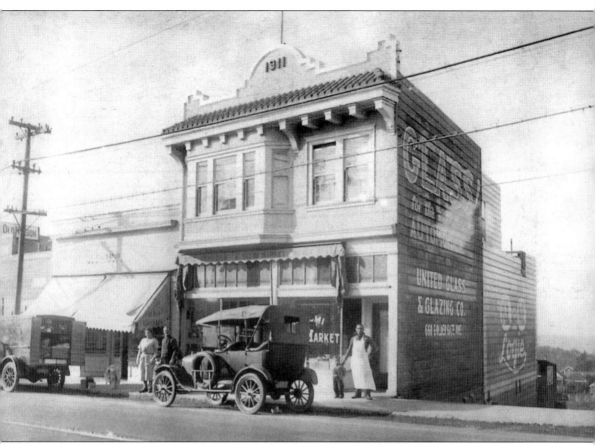

The Selmi Market on Mission Street is seen here in 1923 with Angelo and his son Lloyd standing in front. Angelo and his wife, Zaira (Sarah Spadoni), raised their family on the second floor above the store. Angelo also raised hogs in Colma. Angelo and Zaira are buried in the Italian Cemetery. (Courtesy of Karen Selmi.)

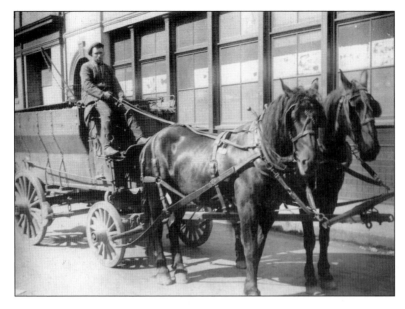

Dario Cortopassi sits on a "swill" wagon in the early 1900s. Swill is wet garbage or discarded food products, which in this case, was transported from San Francisco hotels and restaurants to Colma to feed hogs. Dario and his wife, Rosina, were each 74 years old when they passed away in 1961 and 1973, respectively. (Courtesy of Jenine Cortopassi.)

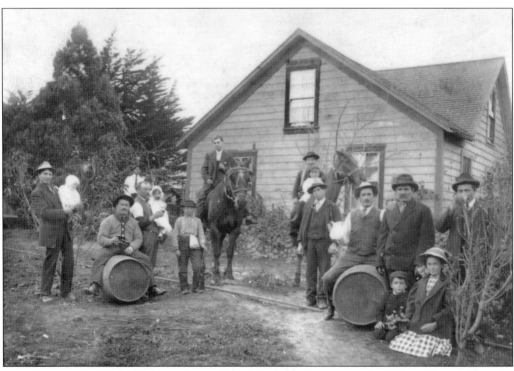

The Lagomarsino Violet Farm was one of the largest flower growers in Colma. Pictured here in 1909 on Collins Avenue in Colma are, from left to right, Joseph James Lagomarsino with baby Lloyd; unidentified sitting on the barrel; the baby in an unidentified man's arms is Geraldine Lagomarsino; an unidentified man behind the group; Paul Delucchi; unidentified man on the first horse; man on second horse is ? Delucchi with the child Dino Lagomarsino; and the remaining six people are unidentified. (Courtesy of the Colma Historical Association.)

There were many nurseries in Colma as mentioned in the Holy Angels Church program. Coastal fog and rich soil has made San Mateo County a mecca for flower businesses for over 100 years. (Courtesy of the Colma Historical Association.)

23

Paul Delucchi is pictured here in his shop on El Camino Real. Three generations of Delucchis have operated a flower shop in Colma. Paul came from the "old country," or Italy, and was Colma's mayor during World War II. Today his son Larry and his grandson Paul manage the shop. (Courtesy of Larry Delucchi.)

Violets were one of the main flowers grown in Colma from 1908 to 1942. By 1916, over 450 acres in Colma were devoted to raising violets. One hundred dozen bunches, each bunch consisting of 40 flowers and 20 leaves, were taken to San Francisco every day. Farmers such as Tony and John Podesta, Bert Lagomarsino, and the Lanza family grew violets. (Courtesy of the estate of Emma Ver-Linden.)

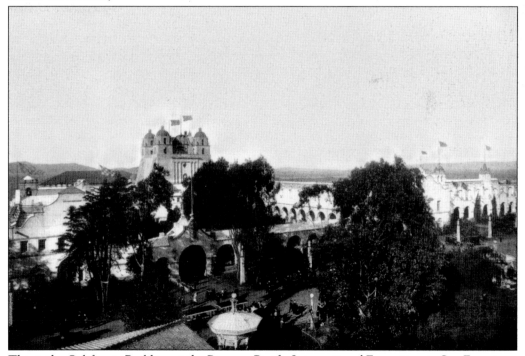

This is the California Building at the Panama-Pacific International Exposition in San Francisco, where in 1915, over 12,000 bunches of Colma-grown violets were handed out to visitors. (Courtesy of the estate of Emma Ver-Linden.)

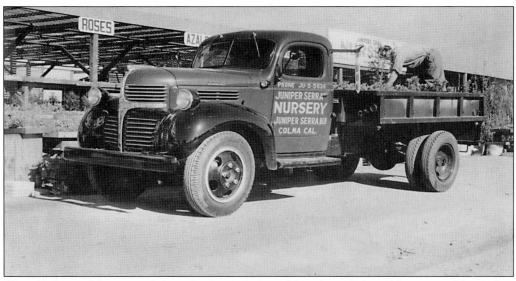

This is a flower-delivery truck from the Junipero Serra Nursery in Colma. (Courtesy of the Colma Historical Association.)

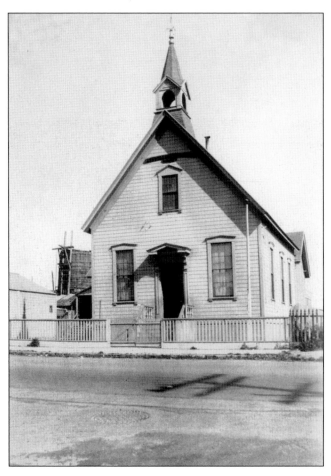

In 1856, one of the first buildings erected in Colma was the Colma Pioneer School House. Pictured here in the 1930s, the schoolhouse was located near Mission Street and Old San Pedro Road. Near it, a railroad depot was built around 1863, and it was called the School House Station. (Courtesy of the estate of Emma Ver-Linden.)

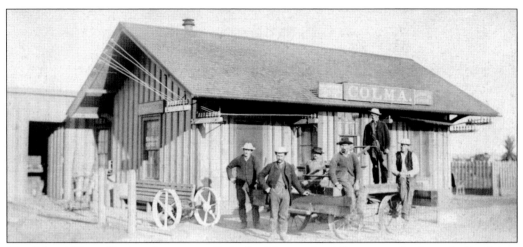

The School House Station depot was called a "waiting station." Five years after it was built, Colma was connected to a statewide railway system, and resident farmers began to ship their products to distant markets. For example, in 1894, the Colma Vegetable Grower Association reported shipping 1,742,825 pounds of cabbage to markets. (Courtesy of the estate of Emma Ver-Linden.)

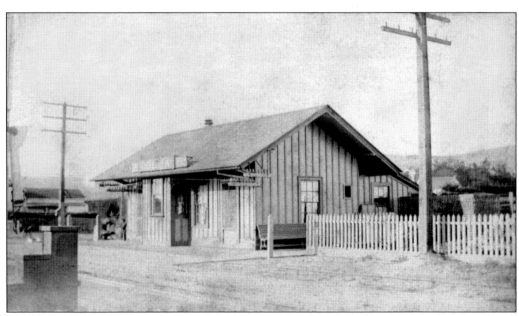

The Colma depot was moved to at least three different locations. In 1995, it was moved to its present site on Hillside Boulevard and F Street. The photographs on this page were taken by C. F. Merrill, who also published the *Colma News*. (Courtesy of the estate of Emma Ver-Linden.)

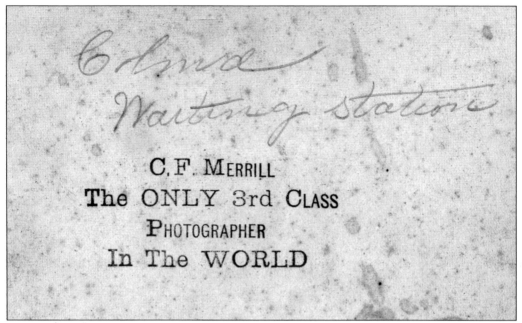

C Lma Waiting Station

C. F. MERRILL
The ONLY 3rd CLASS
PHOTOGRAPHER
In The WORLD

Merrill was a "humble photographer" of Colma history. (Courtesy of the estate of Emma Ver-Linden.)

SOUTHERN PACIFIC RAILROAD,
(NORTHERN DIVISION.)

Commencing Monday, April 21st, 1879, Passenger Trains

WILL LEAVE AS FOLLOWS:

FROM SAN FRANCISCO DAILY	DAILY Sundays Excepted		SUN-DAYS ONLY	DAILY	SUN-DAYS ONLY	DAILY	DAILY	Distance from SAN FRAN.	STATIONS.	Distance from SOLEDAD.	TOWARD S.F. DAILY	DAILY Sundays Excepted			SUN-DAYS ONLY	DAILY	DAILY	SUN-DAYS ONLY
P.M.	P.M.	P.M.	P.M.	P.M.	A.M.	A.M.	A.M.				A.M.	A.M.	A.M.	A.M.	A.M.	P.M.	P.M.	P.M.
Lv.	Lv.	Lv.	Lv.	Lv.	Lv.	Lv.	Lv.				Ar.	Ar.	Ar.	Ar.	Ar.	Ar.	Ar.	Ar.
6.50	5.00	4.25	3.30	3.30	10.40	9.30	8.20	0	San Fran.	142-9	6.40	8.30	9.10	10.00	10.00	3.40	6.40	8.15
6.45	5.14	4.39	3.45	3.45	10.55	9.46	8.36	3-4	Valencia St.	139-5	6.25	8.16	8.56	9.46	†9.45	3.25	6.25	8.00
6.50	5.18			†3.49	10.59	9.49	8.41	4-6	BERNAL	138-3	6.20	8.13			†9.42	3.20	6.21	7.55
6.56	5.23			†3.54	11.04	9.55	8.48	6-9	SAN MIGUEL	126-0	6.13	8.08			†9.37	3.15	6.15	7.50
7.03	5.28			†3.59	11.09	10.01	8.55	9-2	COLMA	133-7	6.05	8.02			†9.32	3.10	6.08	7.44
7.10	5.34	4.57		†4.05	11.16	10.08	9.03	12-2	BADEN	130-7	5.58	7.55			†9.26	3.02	6.00	7.36
7.17	5.39			†4.10	11.21	10.14	9.10	14-5	SAN BRUNO	128-6	5.48	7.50			†9.22	2.57	5.53	7.31
7.25	5.45	5.07	4.15	4.15	11.28	10.19	9.17	17-0	MILLBRAE	125-9	5.40	7.44	8.29	9.17	9.17	2.50	5.45	7.25
7.30	5.51			†4.20	11.33	10.26	9.21	19-2	OAK GROVE	123-7	5.31	7.39			†9.12	2.45	5.36	7.19
7.39	5.55	5.15	4.24	4.24	11.33	10.31	9.25	21-1	SAN MATEO	121-8	5.25	7.34	8.21	9.09	9.09	2.40	5.30	7.13
7.48	6.03		†4.31	†4.31	11.48	10.41	9.34	25-1	BELMONT	117-8	5.10	7.25		†9.02	†9.02	2.30	5.21	7.03
7.55	6.11	5.27	4.38	4.38	11.56	10.50	9.41	28-6	REDWOOD	114-3	5.02	7.18	8.08	8.55	8.55	2.21	5.12	6.54
				P.M.														
8.00	6.16			†4.43	12.01	10.56	9.46	30-9	FAIR OAKS	112-0	4.54	7.13			†8.50	2.15	5.05	6.48
8.05	6.20	5.35	4.47	4.47	12.05	10.59	9.49	32-1	MENLO PARK	110-8	4.50	7.10	8.01	8.47	8.47	2.12	5.01	6.44
		5.41	4.53	4.53	12.12	11.06	9.56	34-9	MAYFIELD	108-0			7.55	8.41	8.41	2.05	4.53	6.37
		5.48	5.01	5.01	12.22	11.15	10.05	39-1	MTN. VIEW	103-8			7.48	8.34	8.34	1.56	4.44	6.27
			†5.07	†5.07	12.29	11.23	10.11	41-9	MURPHYS	101-0			†7.42			1.49	4.38	6.20
		†5.57		†5.11	12.34	11.28	10.16	43-9	LAWRENCES	99-0			†7.37		†8.25	1.44	4.33	6.15
		6.04	5.17	5.17	12.43	11.36	10.24	47-4	SANTA CLARA	95-5			7.30	8.19	8.19	1.36	4.26	6.06
		6.10	5.23	5.23	12.55	11.43	10.30	50-0	SAN JOSE	92-9			7.25	8.13	8.13	1.30	4.20	6.00
		†5.49			1.15			57-3	EDEN VALE	85-6			†7.47			1.04		
		†5.58			1.27			62-8	COYOTE	80-1			†7.37			12.53		
		†6.04			1.34			65-8	PERRYS	77-1			†7.31			12.46		
		6.10			1.40			68-6	MADRONE	74-1			†7.25			12.40		
		†6.15			1.46			71-5	TENNANTS	71-4			†7.20			12.34		
		6.42			2.20			80-3	GILROY	62-6			7.04			12.15		
					2.26			82-5	CARNADERO	60-4						11.55		

This April 21, 1879, passenger-train schedule shows Colma as the sixth stop from San Francisco. (Courtesy of the Colma Historical Association.)

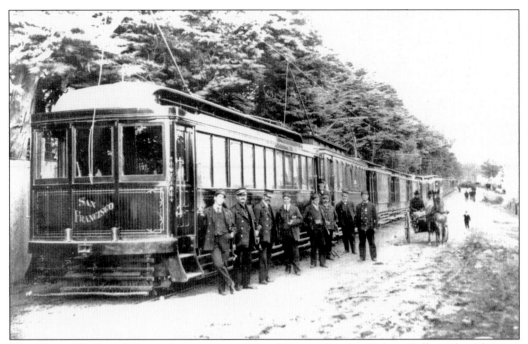

The United Railroad Special stopped on School Street for the Colma Kelly-Nelson boxing match in 1903. From 1895 to 1914, Colma was a prizefighting center. (Courtesy of the Colma Historical Association.)

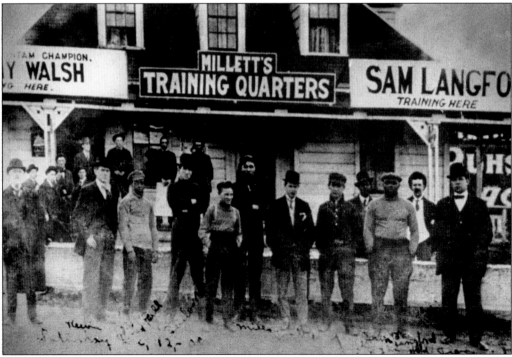

Colma resident Joe Millet operated boxing-training quarters (Millet's Corner) until 1914, when prizefighting was declared illegal in Colma. (Courtesy of the Colma Historical Association.)

Hanging in the Colma Historical Museum is this sketch by Frank Maffei of a Southern Pacific train at the Colma depot. (Courtesy of Frank Maffei.)

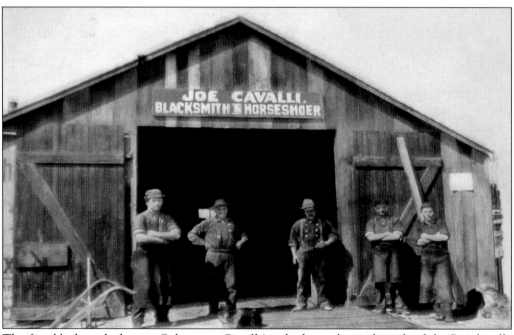

The first blacksmith shop in Colma was Cavalli's, which was located north of the Brooksville Hotel. It was in operation from 1883 to 1924. The proprietor, Joe Cavalli, is seen standing on the left. (Courtesy of Blandin Molloy.)

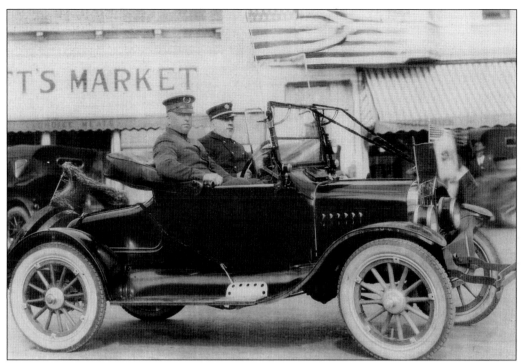

Silvio Landini (driver's seat), the first constable of Colma, is sitting next to the new marshal, Joe Cavalli, of the town of Lawndale. Cavalli was marshal from 1924 to 1942, and he was the first chief of police of Colma, a position he held from 1942 to 1946. This photograph was taken on Mission Street near Market Street. (Courtesy of the Colma Historical Association.)

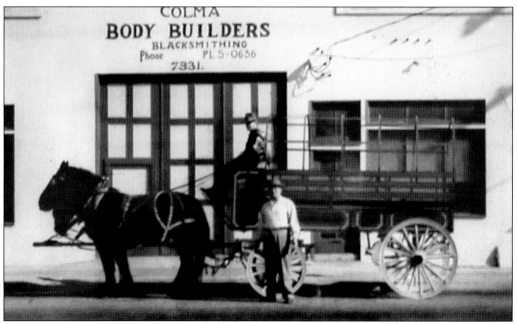

This is the Colma Body Builders blacksmithing shop in 1904. (Courtesy of Laura Allen, Colma assistant city manager.)

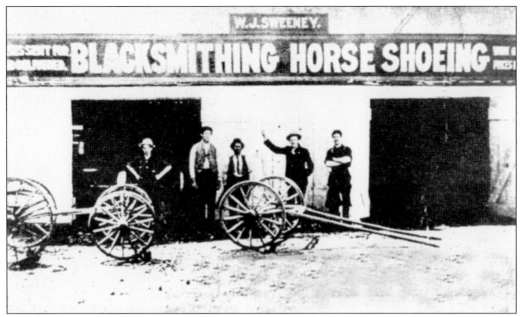

Here is the Sweeney Blacksmithing shop on Mission Street. Sweeney later became an automobile dealer, moving from horses to horseless carriages. (Courtesy of the History Guild of Daly City/Colma.)

Pictured here is the Colma Hotel on Mission Street on the east side of E Street in 1905. Colma's population began to grow after the 1906 earthquake. Many people fled San Francisco south to Colma, and many stayed even after San Francisco was rebuilt. (Courtesy of the Colma Historical Association.)

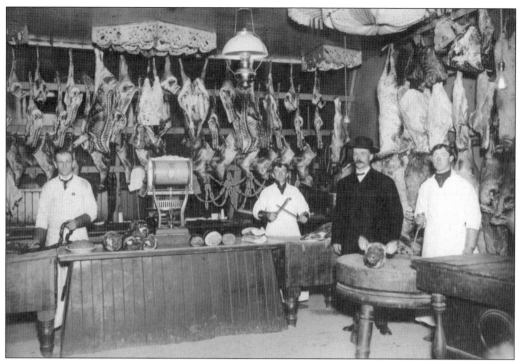

This is the Pacific Meat Market in Colma in 1908. The man in the hat is James Casey, a businessman who was county supervisor from 1908 to 1916. He was known as "Good Roads Casey," as he was a prime mover in getting roads built. (Courtesy of the History Guild of Daly City/Colma.)

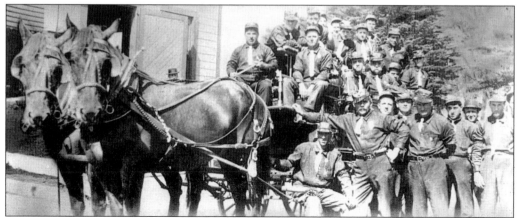

Pictured here is the Colma volunteer fire department at the beginning of the 20th century. (Courtesy of the History Guild of Daly City/Colma.)

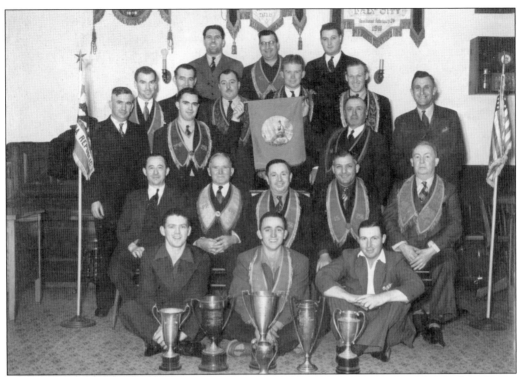

This is a meeting of the Order of the Owls. Originally founded in St. Louis, the Owl organization's purpose is to have fun. Local groups were called "nests," and the head owl was called the "sapient screecher." Early members of Colma's chapter included Robert Selicani, Warren Van Dorn, William Popino, William Bracken, Chester Pratt, William Ottoboni, Antone Morchio, professor W. J. Savage, Angelo Benedetti, L. Wallace, Louis Lagomarsino, and T. O. Reilly. (Courtesy of the estate of Emma Ver-Linden.)

The gold-braided orange sash worn by members indicated the El Carmelo Parlor 256 of the Native Sons of the Golden West. Due to a decline in membership, the Colma chapter, which started in 1910, came to an end in 1987. (Courtesy of the estate of Emma Ver-Linden.)

These are convention medals and a ribbon from the El Carmelo Parlor that met in the Colma Hall. (Courtesy of the estate of Emma Ver-Linden.)

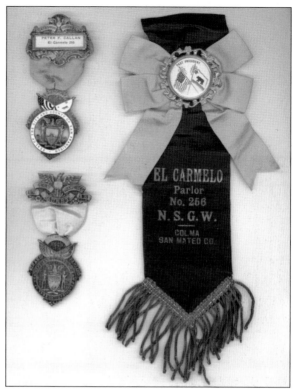

Peter Callan, whose son Jim was married to Emma Ver-Linden's sister Sybil, worked for Cypress Lawn Cemetery. Peter was one of nine children. His younger brother Tom (1890–1979) was a Colma city councilman, hog rancher, and member of the Jefferson school board. (Courtesy of the Colma Historical Association.)

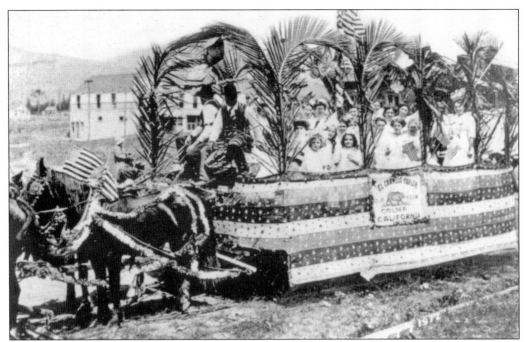

A horse-drawn float features Colma's Native Daughters of the Golden West El Carmelo Parlor at the Fourth of July Parade in 1912. (Courtesy of the Colma Historical Association.)

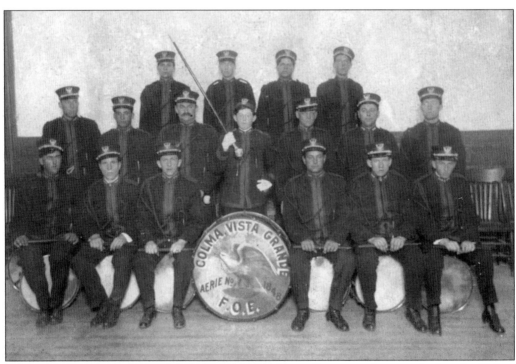

Organized in 1910, the Colma Vista Grande Eagle Drum Corp was photographed at the Colma Hall on June 18, 1912. (Courtesy of the History Guild of Daly City/Colma.)

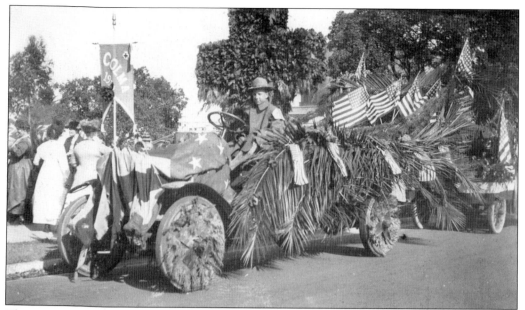

This is a parade on Armistice Day, November 11, 1919, for Colma's returning "doughboys," or men America sent to France during World War I. (Courtesy of the estate of Emma Ver-Linden.)

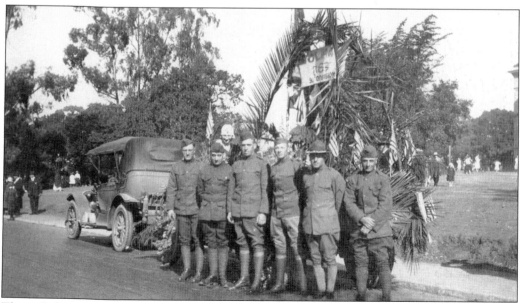

These Colma soldiers, just having returned from World War I, pose for a snapshot. (Courtesy of the estate of Emma Ver-Linden.)

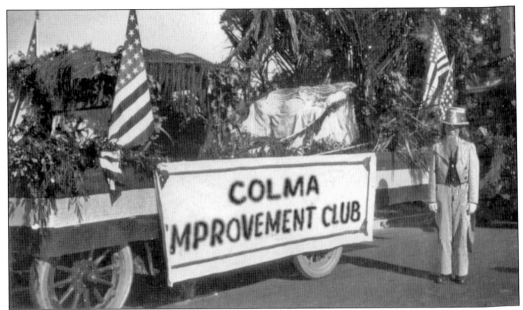

This is the Colma Improvement Club float at the same parade seen on page 37. (Courtesy of the estate of Emma Ver-Linden.)

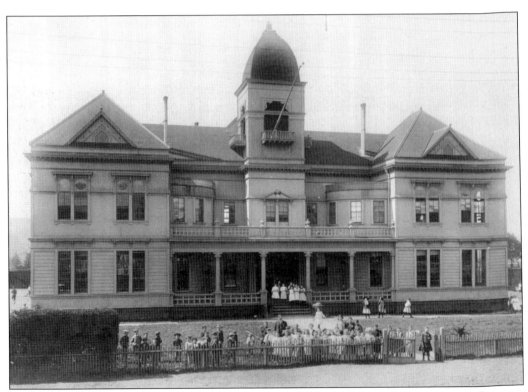

The Jefferson Elementary School, which was built in 1866, supplemented the one-room Pioneer School House. (Courtesy of the Colma Historical Association.)

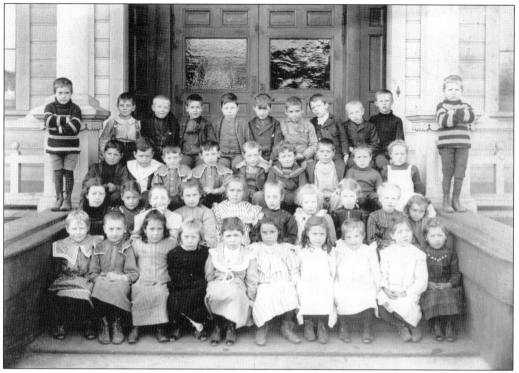

This is either the class of 1904 or 1905 pictured at the Colma schoolhouse. (Courtesy of the estate of Emma Ver-Linden.)

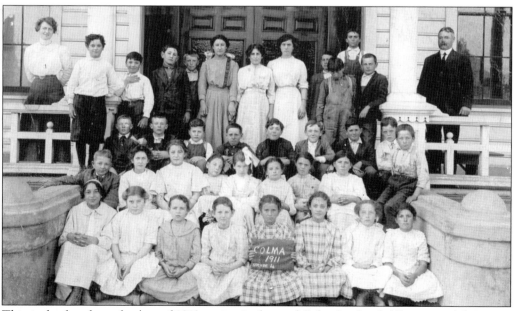

This is the fourth-grade class of 1911 posing in front of Colma's school. (Courtesy of the estate of Emma Ver-Linden.)

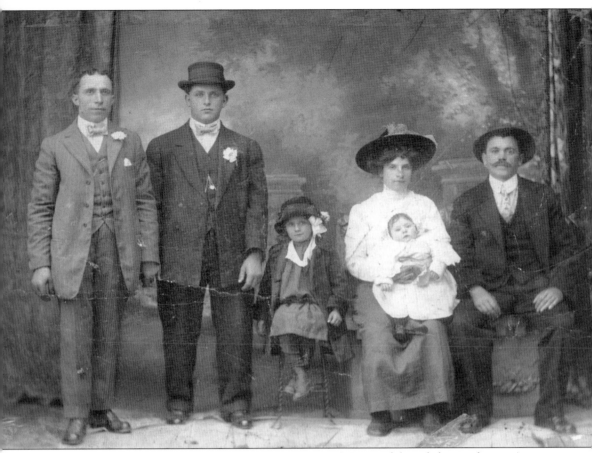

This Colma pioneer family poses for a portrait in 1915. Pictured from left to right are Antonio Garibaldi, Domenic Liberale, Mary Garibaldi, Caterina Garibaldi, Albina Garibaldi, and Emilio Garibaldi. (Courtesy of Albina Garibaldi Parma.)

Two

CEMETERIES AND MONUMENTS

1886–2006

Until 1912, there were about 25 cemeteries located in San Francisco, Colma's northern neighbor. Over the next 30 years, almost all of the bodies in these cemeteries were relocated to Colma, and the San Francisco cemeteries were closed.

Owners of the San Francisco cemeteries had seen the "writing on the wall" as early as the mid-1880s. As the city's population grew, the cemeteries were running out of room. In 1887, Archbishop Patrick Riordan set aside 283 acres of land to serve Catholics in Colma. In another example, the president of the Jewish Temple Emanu-El in 1886 reported the need to acquire larger accommodations for the burial of their dead. Two years later, the Jewish congregation bought land in Colma.

San Francisco city fathers decided officially in 1890 that their city was too small and the available land too valuable to be used for burial grounds. There were to be no future burials in the cemeteries in San Francisco. Later, in 1912, the San Francisco Board of Supervisors ordered the disinterment of the bodies and their removal from the city.

Before their eventual eviction from San Francisco, new cemeteries were built in Colma. Beginning with horse-drawn hearses and followed with daily funeral railroad cars, bodies were moved from San Francisco to the Colma cemeteries. Mourners paid 50¢ a person and caskets were transported in the baggage car for $1. Thousands of disinterred bodies were sent south to Colma. Some bodies were unidentifiable, and they were put into mass graves.

Among the dead in Colma, there are kings, an emperor, Russian rulers, Civil War generals, politicians, and many other people and animals.

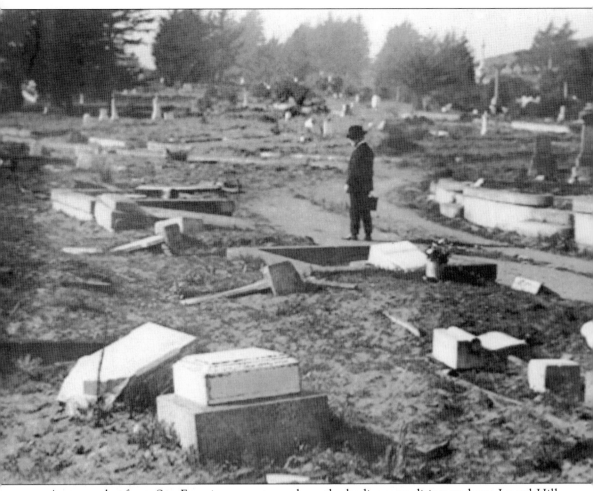

An example of one San Francisco cemetery where the bodies were disinterred was Laurel Hill Cemetery on Lone Mountain. Most of the bodies went to Cypress Lawn. (Courtesy of the Colma Historical Association.)

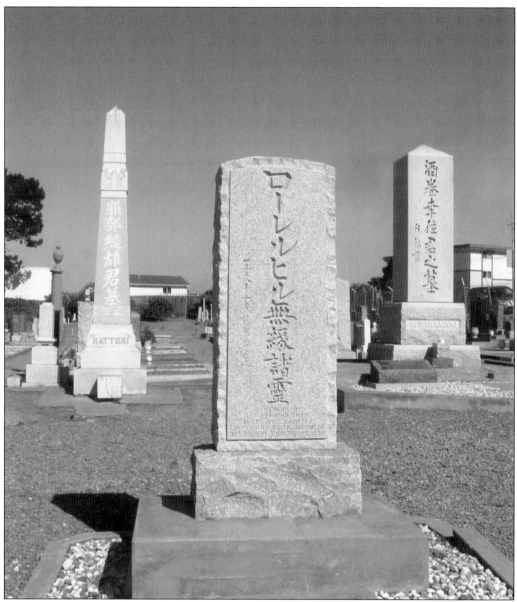

At the Japanese Cemetery in Colma, there is a mass grave and monument for the Japanese bodies moved from Laurel Hill Cemetery in San Francisco. The writing on the bottom reads, "In memory of 107 remains from Laurel Hill Cemetery devoted to Calif. Japanese. Benevolent Society October 1959." (Courtesy of the author.)

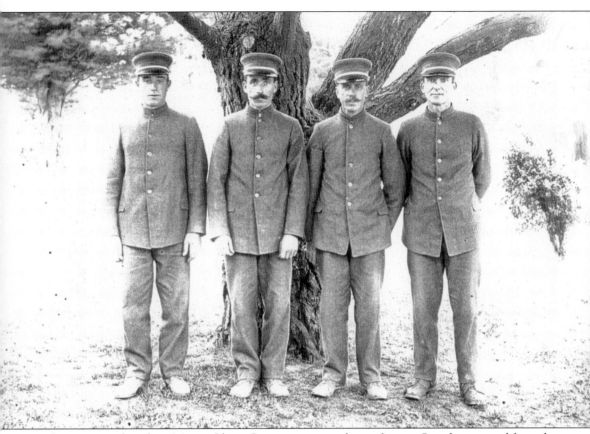

Cemetery workers from Mount Olivet Cemetery pose in front of a tree. Standing second from the left is Frank Maffei's father. Frank wrote, "My dad worked exhuming bodies at Lone Mountain and Laurel Hill cemeteries in San Francisco in the late 1930s. It was a hard job, and nasty because to the conditions of those who were buried. There were many tree roots and water in the coffins. A lot of bodies were from the '06 Quake and had been burned. They were buried 'as is,' burned clothes and all. Dad found many coins on them from the 1870s–1880s. A doctor had even been buried with all of his 'tools.' My dad assisted in removing the first governor of California. A special hearse came to pick up the body, which I think he said was in a special sealed casket, and brought to Colma. All others were put in a 'common container.' " (Courtesy of the Colma Historical Association.)

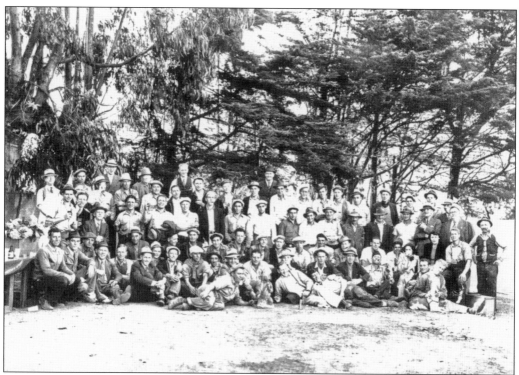

Workers celebrate with a picnic on the last day of removal of bodies from San Francisco cemeteries in 1941. The man in the white hat and eyeglasses, on the right and in line with the trunk of the cypress tree, is Peter S. Barsi. Eventually there would be 17 cemeteries in Colma. (Courtesy of the estate of Emma Ver-Linden.)

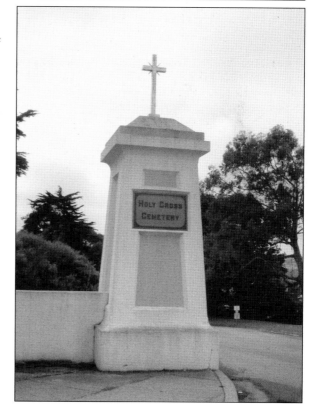

Here is the Hillside entrance to Holy Cross Cemetery, which is the largest and oldest (1887) in Colma. Founded by Archbishop Riordan, Holy Cross is 283 acres in size and is located on Mission Road. (Courtesy of the author.)

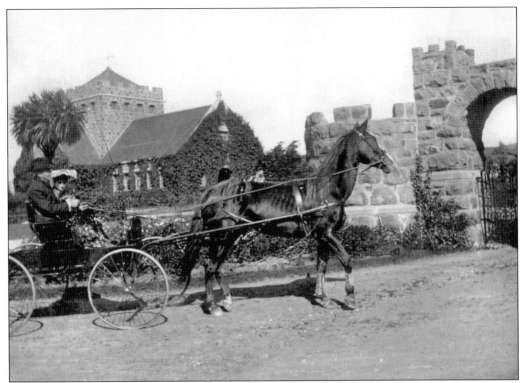

This is farmer Joseph Lagomarsino driving a horse-and-buggy in front of Mount Olivet Cemetery. Almost 39,307 bodies were moved from San Francisco to Holy Cross in Colma. For example, the body of Edward Higgins (1821–1875), a Civil War general, was moved from Mount Calvary Cemetery in San Francisco to Colma. (Courtesy of the Colma Historical Association.)

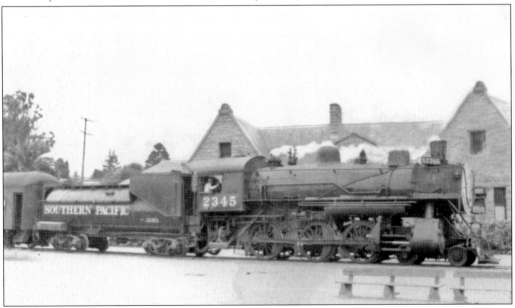

A Southern Pacific train stops at the Colma Passenger Station, which became the administration building of Holy Cross Cemetery. (Courtesy of Al Capurro.)

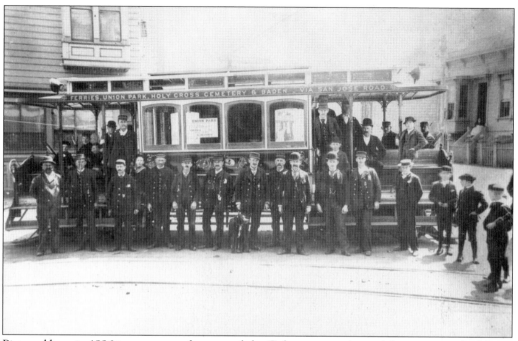

Pictured here in 1896 is a streetcar that served the Colma cemeteries and dog racing at the Union Coursing Park. (Courtesy of the History Guild of Daly City/Colma.)

Pictured here is Cypress Lawn Cemetery in 1940. Funeral cars from San Francisco transferred caskets at Holy Cross Railroad Station to the cemeteries. (Courtesy of Tom Gray.)

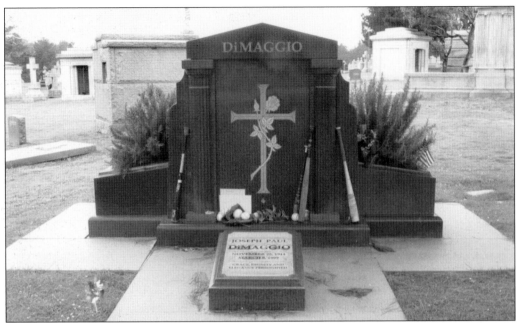

Buried in Holy Cross Cemetery, baseball great Joe DiMaggio (1914–1999) was best known as the "Yankee Clipper." DiMaggio played for the San Francisco Seals and the New York Yankees. He was also at one time married to the actress Marilyn Monroe. Other notables buried in Holy Cross include Archbishop Patrick W. Riordan; Archbishop Joseph S. Alemany; Faxon Atherton, for whom the town of Atherton was named; sculptor Benjamin Bugano; and Amadeo Peter "A. P." Gianni, who founded Bank of America. (Courtesy of the author.)

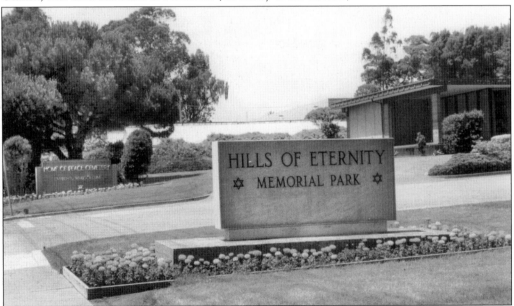

Two of four Jewish cemeteries in Colma, the Hills of Eternity (1889) and the Home of Peace (1889), are on adjoining properties with one office. Burials in Jewish cemeteries are mostly side-by-side, which take up more space and require more maintenance to the grounds. (Courtesy of the Colma Historical Association.)

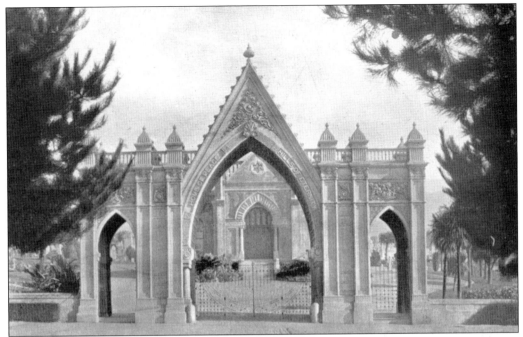

The beautiful and ornate entrance to the Home of Peace and the Hills of Eternity cemeteries was destroyed in the earthquake of 1906. Notable individuals buried at the Home of Peace include Levi Strauss, Adolph Sutro (known as the "Silver King"), and Ignatz Steinhart (for whom the Steinhart Aquarium was named). (Courtesy of Temple Emanu-El *Temple Chronicle*.)

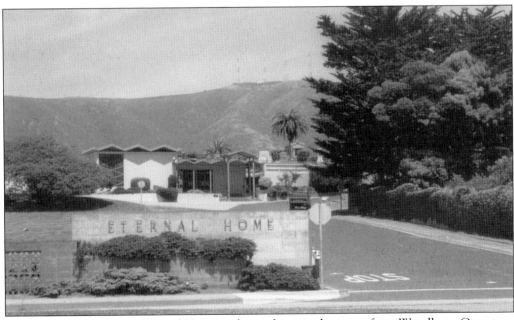

A third Jewish cemetery, Eternal Home, is located across the street from Woodlawn Cemetery. Rock and roll musician promoter Billy Graham is buried there. (Courtesy of the Colma Historical Association.)

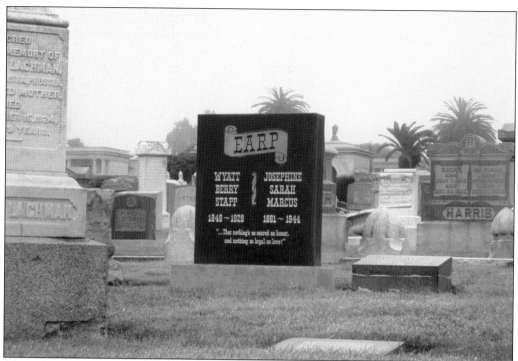

This is the monument to a famous western marshal, Wyatt Earp, at the Hills of Eternity. Earp participated in the gunfight at the O.K. Corral in Tombstone, Arizona, on October 26, 1881. He died in Los Angeles in 1929. His wife, Josephine, was Jewish, and she brought Earp's cremated remains to Colma to her family plot. (Courtesy of the author.)

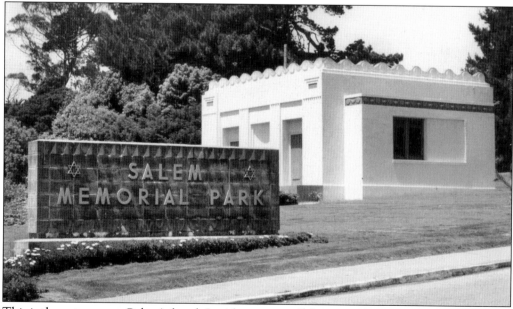

This is the entrance to Colma's fourth Jewish cemetery, Salem, seen here in 1999. It was founded in 1891. (Courtesy of the Colma Historical Association.)

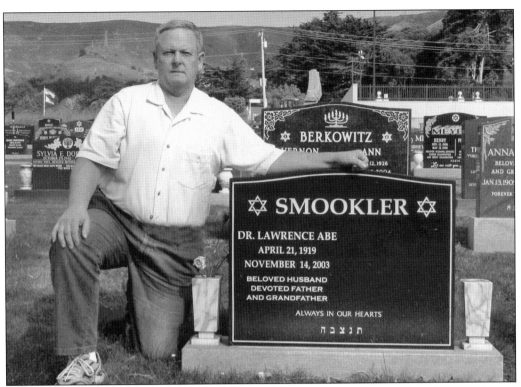

Author Michael Smookler pays his respects at his father's grave in Salem Cemetery.

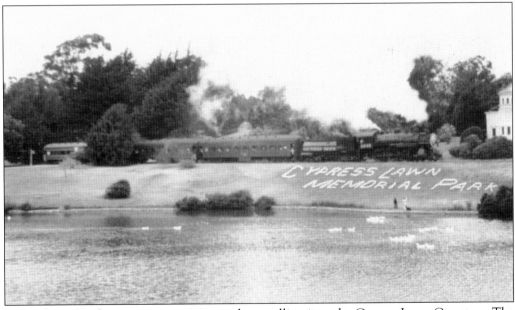

A Southern Pacific passenger train is seen here pulling into the Cypress Lawn Cemetery. The manicured green lawns and gentle slopes of Cypress Lawn make this one of the most beautiful cemeteries in Colma. Founded in 1892, it is a non-sectarian cemetery whose main entrance is on Mission Street. (Courtesy of Al Capurro.)

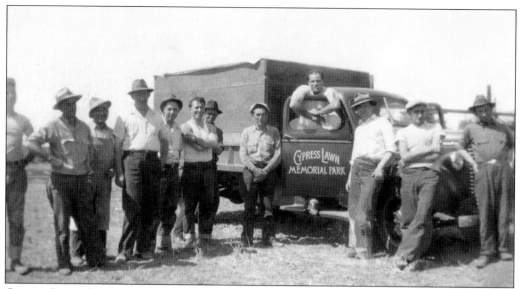

Cypress Lawn Cemetery workers take a break for the photographer. (Courtesy of the Colma Historical Association.)

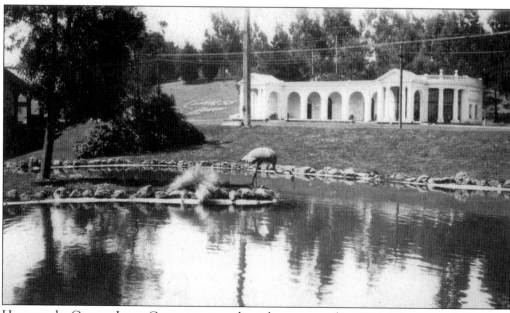

Here are the Cypress Lawn Cemetery grounds as they appeared in 1920. (Courtesy of the estate of Emma Ver-Linden.)

This certificate of cremation from Cypress Lawn Cemetery, dated May 24, 1932, contains vital information about the deceased. (Courtesy of the Colma Historical Association.)

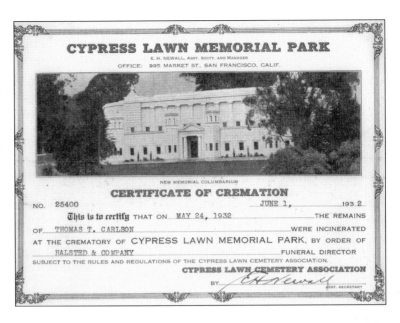

CYPRESS LAWN MEMORIAL PARK
E. H. NEWALL, Asst. Secty. and Manager
OFFICE: 995 MARKET ST., SAN FRANCISCO, CALIF.

NEW MEMORIAL COLUMBARIUM

CERTIFICATE OF CREMATION

NO. 25400 JUNE 1, 193 2

This is to certify THAT ON MAY 24, 1932 THE REMAINS

OF THOMAS T. CARLSON WERE INCINERATED

AT THE CREMATORY OF **CYPRESS LAWN MEMORIAL PARK**, BY ORDER OF

HALSTED & COMPANY FUNERAL DIRECTOR

SUBJECT TO THE RULES AND REGULATIONS OF THE CYPRESS LAWN CEMETERY ASSOCIATION.

CYPRESS LAWN CEMETERY ASSOCIATION

BY _CH Newall_

ASST. SECRETARY

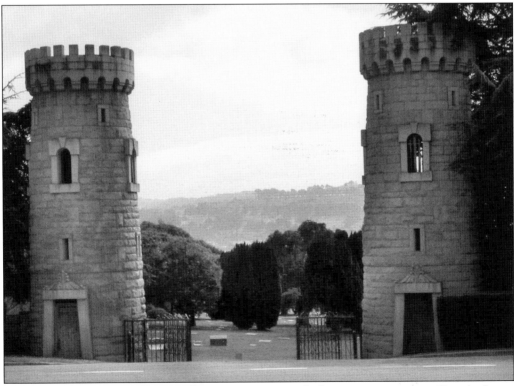

Known as the Norman Towers, these structures mark the rear entrance to Cypress Lawn Cemetery. Historical figures of note buried there include David Broderick, who was a U.S. Senator shot and killed by a former chief justice of the California State Supreme Court, in a duel in Daly City in 1859. Also, "Silver King" James Flood is buried in Cypress Lawn. (Courtesy of the author.)

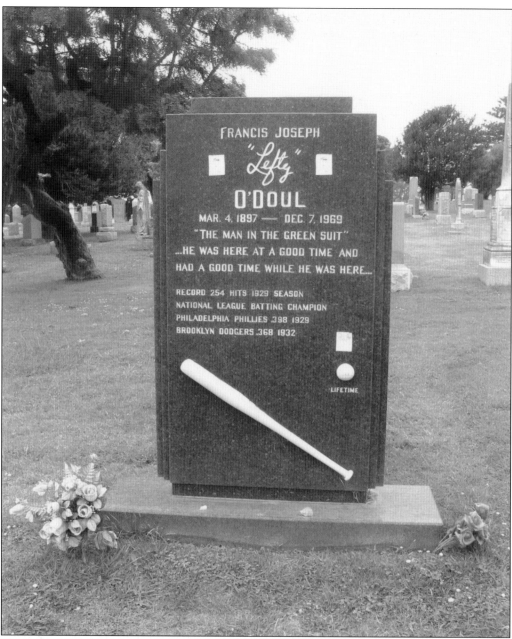

FRANCIS JOSEPH

"Lefty"

O'DOUL

MAR. 4, 1897 — DEC. 7, 1969

"THE MAN IN THE GREEN SUIT"

...HE WAS HERE AT A GOOD TIME AND

HAD A GOOD TIME WHILE HE WAS HERE...

RECORD 254 HITS 1929 SEASON

NATIONAL LEAGUE BATTING CHAMPION

PHILADELPHIA PHILLIES .398 1929

BROOKLYN DODGERS .368 1932

LIFETIME

The Lefty O'Doul monument was made by Jim Salacci of Bocci and Sons. Lefty O'Doul (1897–1969) was a pitcher and an outfielder who played in the National League from 1925 to 1932. He had an outstanding career .349 batting average. From 1935 to 1951, Lefty played for and managed the San Francisco Seals in the Pacific Coast League. He is credited with introducing the sport of baseball to Japan. (Courtesy of the author.)

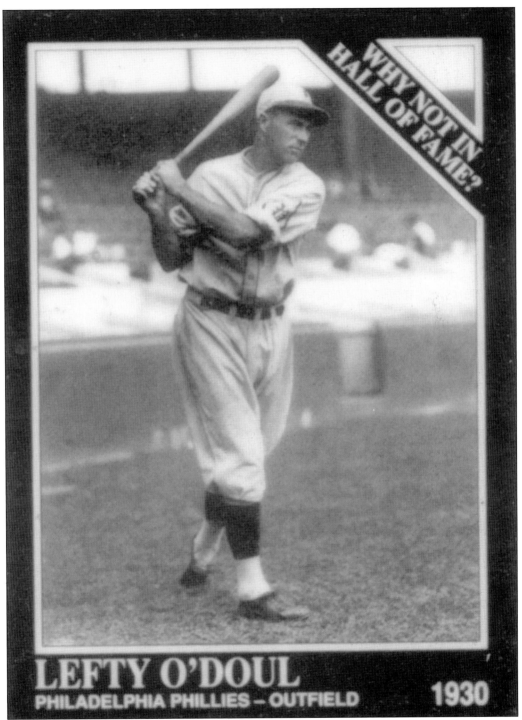

WHY NOT IN HALL OF FAME?

LEFTY O'DOUL
PHILADELPHIA PHILLIES — OUTFIELD **1930**

In the year 2006, Lefty's name appeared on the ballot for baseball's Hall of Fame. (Courtesy of Lefty O'Doul restaurant on Powell Street in San Francisco.)

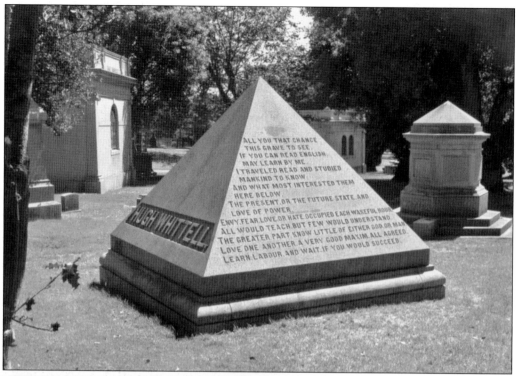

The monument to Hugh Whittell was moved from Lone Mountain Cemetery in San Francisco to Colma. Grave monuments are found in many shapes, sizes, and colors. Some are adorned with statuary, urns, angels, dogs, toys, and sports equipment.

Charles de Young (1845–1880) was the cofounder and managing editor of the *San Francisco Chronicle* newspaper. He was shot and killed at a young age by a political enemy. It started when the *Chronicle* opposed the Reverend Isaac S. Kalloch as a candidate for mayor and ran an unfavorable story about him. Kalloch did not dispute the story but retaliated by assaulting the character of de Young's mother. De Young was so upset that he shot and slightly wounded Kalloch. After Kalloch won the election, his son went to the newspaper's offices and shot and killed de Young.

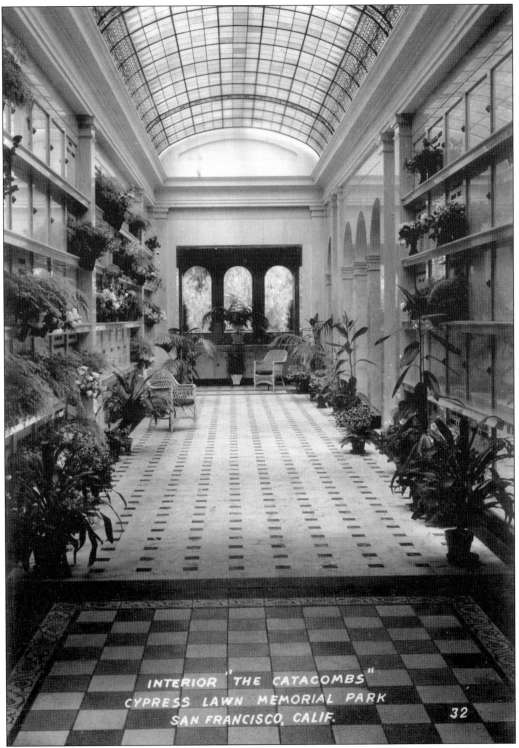

INTERIOR "THE CATACOMBS"
CYPRESS LAWN MEMORIAL PARK
SAN FRANCISCO, CALIF. 32

These are the catacombs at Cypress Lawn Cemetery. Many of the cemeteries in Colma have columbariums. (Courtesy of the Colma Historical Association.)

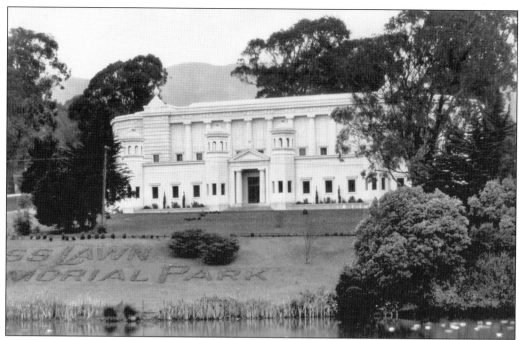

Construction of the largest columbarium in the world at the time was begun at Cypress Lawn Cemetery in 1927. The stock-market crash of 1929 stopped construction work on the columbarium. It has yet to be completed, and only a portion of the building is occupied. (Courtesy of the Colma Historical Association.)

The main entrance to the Italian Cemetery is on F Street. As the only Italian cemetery in the United States, it was opened in Colma in 1899. It was established by the Italian Mutual Benevolent Society, and 50,000 people are buried in this 40-acre cemetery. (Courtesy of Andy Canepa.)

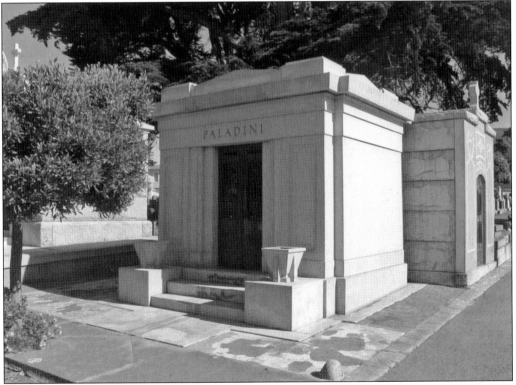

ITALIAN CEMETERY.

No. 96 Colma, San Mateo Co., Cal., 190

Received from *Avelino Maccaeno*

Soma $ 5.00 Dollars

for care and watering Grave, 74, Block, 68

from *Agusto 1 1902* to *Agusto 1 1903*

J Logomorsino

Here is a receipt for the care and watering of Grave No. 74 for one year. Including a mixture of granite vaults, family chapels, and mausoleums, there are about 300 burials a year in this cemetery. (Courtesy of the Colma Historical Association.)

One of two "kings" buried in the Italian cemetery, Achille Paladini (1843–1921) was known as the "Fish King." (Courtesy of the author.)

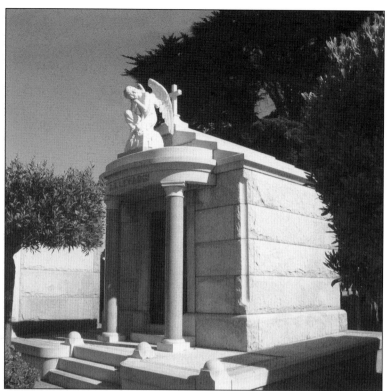

This is a family chapel for G. B. Levaggi (1840–1920), who was known as the "Olive Oil King." There are few chapels built anymore, because they are so expensive; the last one constructed in 1987 cost $500,000. (Courtesy of the author.)

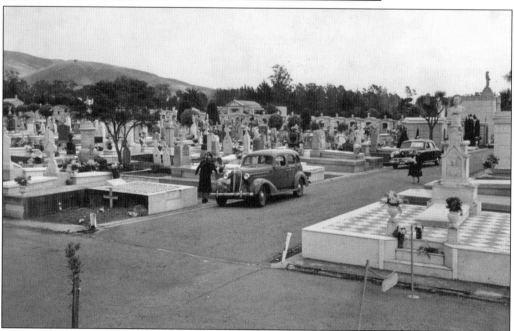

Pictured is the Italian Cemetery in 1948. According to Andrew Canepa, the assistant manager, the Italian Cemetery is not running out of space because there are few side-by-side burials in this cemetery. Cremations and double burials, one on top of another, take up less space. (Courtesy Andy Canepa.)

Lee Marsigli's uncle, Guiseppe
Marsigli, who came to Colma from
Italy in 1908, lived on Garibaldi Street
and operated a flower shop on Hillside
Boulevard. (Courtesy of the author.)

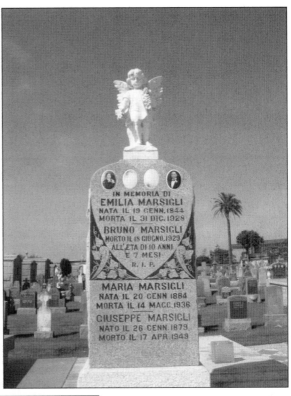

This is a photo-ceramic
memorial portrait of Guiseppe
Marsigli on his monument.
There are about 1,000 of
these portraits in the Italian
Cemetery. (Courtesy of
the author.)

61

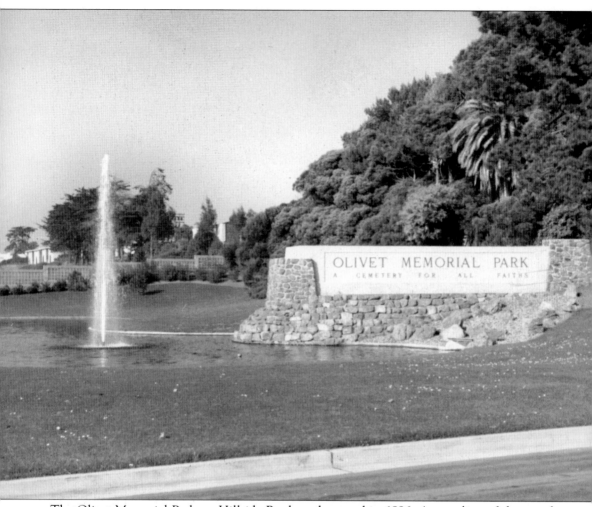

The Olivet Memorial Park on Hillside Boulevard opened in 1896. A sampling of the people buried in the Olivet includes Civil War general George Stone and Mattrup Jensen, the man who is considered the "Father of Colma." (Courtesy of the Colma Historical Association.)

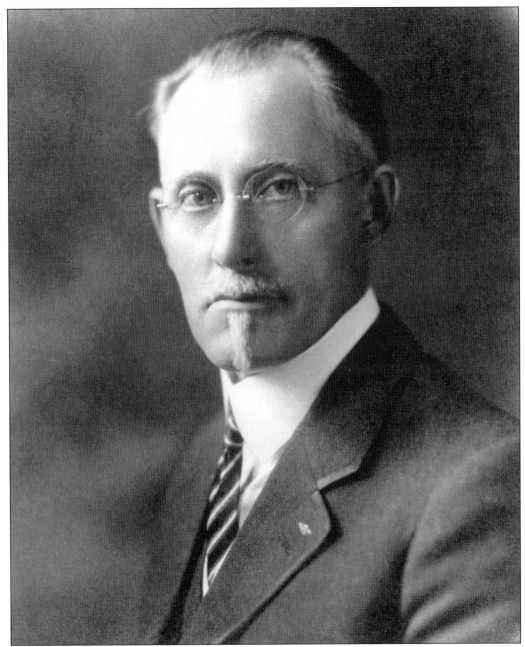

Mattrup Jensen, who worked for Cypress Lawn and Olivet cemeteries for 44 years, felt that Colma cemeteries should be made to look like outdoor cathedrals. (Courtesy of the Colma Historical Association.)

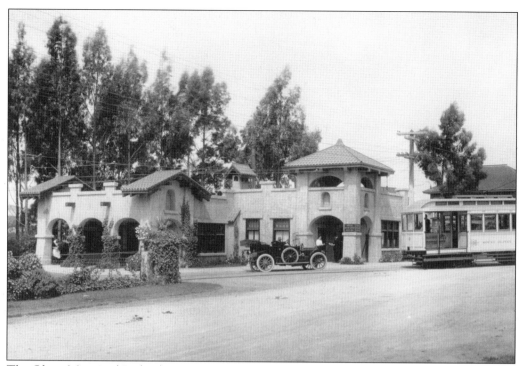

The Olivet Memorial Park administration building in 1910 contained waiting rooms, restrooms, and a floral booth. On the right in the photograph is an Olivet streetcar. (Courtesy of Colma Historical Association.)

An example of "taking the money with you," this Olivet family chapel reportedly cost $2 million dollars to build. It is not yet occupied. (Courtesy of the author.)

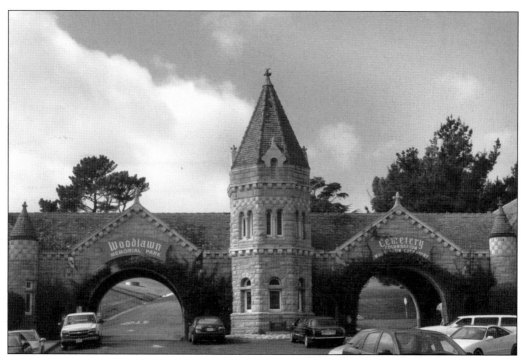

Woodlawn Memorial Park, also known as the Masonic Burial Ground, started in 1905. Approximately 19,900 bodies were moved from San Francisco to the Woodlawn Cemetery. Three noteworthy burials here include "Cattle King" Henry Miller (1827–1916), who founded the cattle firm of Miller and Lux; Etienne Guittard (1838–1899), who founded the oldest family-owned chocolate company in the United States; and Joshua Norton (1819–1880), who proclaimed himself emperor of the United States and the protector of Mexico. (Courtesy of the author.)

Etienne Guittard and several members of his family are buried in Colma cemeteries. (Courtesy of the E. Guittard Company.)

SINCE 1868

E. GUITTARD

VINTAGE CHOCOLATE MAKING IN THE FRENCH TRADITION

Here is the Etienne Guittard chocolate label. (Courtesy of the E. Guittard Company.)

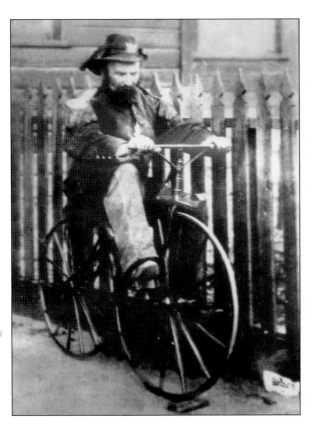

Joshua Norton was a peculiar individual, who in death is still a legendary figure. Norton loved the English monarchy. He believed in the divine right of kings, so his friends would often call him "Emperor." When he lost money and that of some of his friends in the rice-merchant business in 1853, he also lost his mind. He became a recluse, and whenever he appeared on the streets of San Francisco, he was dressed in a Napoleonic military uniform. Norton issued edicts, decrees, and proclamations. He advocated social reform for African Americans and maritime workers. Every saloon gave him free lunch. He died on January 8, 1880, and an estimated 10,000 people came to his funeral. The anniversary of his passing often brings a colorful parade to his grave site. In the 1960s, the *San Francisco Chronicle* sponsored annual Emperor Norton treasure hunts.

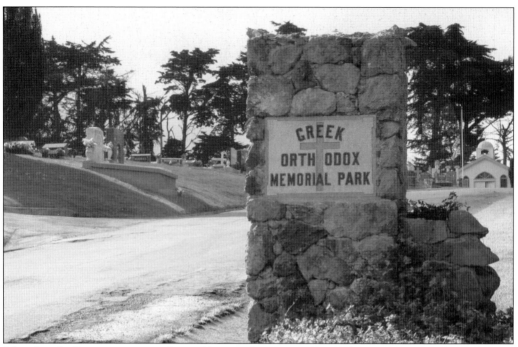

The Greek Cemetery opened in 1934 on the west side of El Camino Real. (Courtesy of the author.)

Pictured is the construction of a mausoleum in the Greek Cemetery in 1937. Joe Bocci is inside the structure, Ivo Antroccoli (grey shirt) is holding a shovel, Nell Martucci (white shirt, brim hat) is holding a shovel, and Sippi Luccesi (baseball hat) is standing. The other man is unidentified. In the background is a 1934 Dodge truck. (Courtesy of Steve Doukas.)

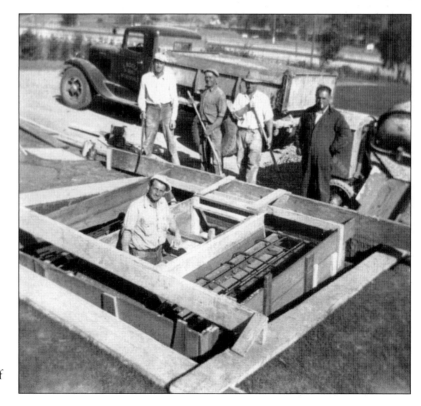

Joe Bocci constructed this mausoleum. Two marble lions flank the doorway to protect its inhabitants. The Doukas family's operation of the Greek Orthodox Memorial Park began in 1934. Today it is managed by Steve J. N. Doukas. (Courtesy of the author.)

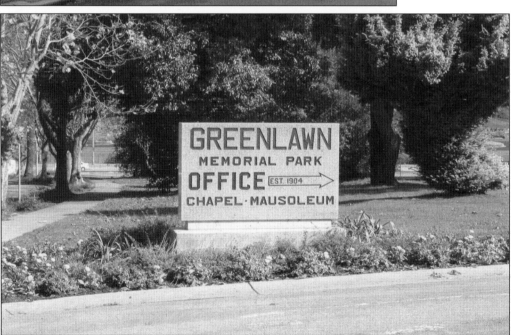

Greenlawn Memorial Park, also called the Odd Fellows Cemetery, began in 1903. Among the residents at Greenlawn are mayor of San Francisco James Rolph (1869–1934) and Michael Gray (1827–1906), the founder of the California Tombstone town site. (Courtesy of the author.)

The Japanese Cemetery is the smallest in Colma. Just four acres of barren land, the cemetery includes a columbarium, a monument for American-Japanese soldiers who fought in World War II, and graves of two "kings" including Keisaburo Koda (1882–1964), who was the "Rice King" and founder of Koda Farms. It is cared for by the Japanese Benevolent Society. (Courtesy of the author.)

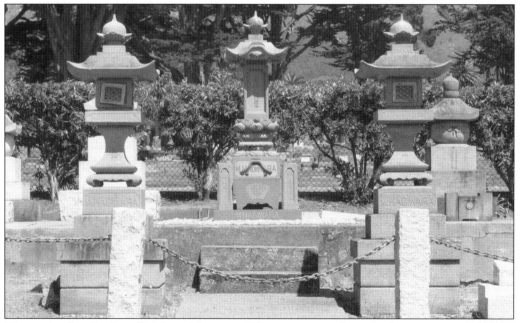

This is the family plot of Makoto Hagiwara. The stones were brought from Japan to build the monument. Hagiwara, who died in 1925, was the creator of the Japanese Tea Garden in Golden Gate Park in San Francisco. (Courtesy of the author.)

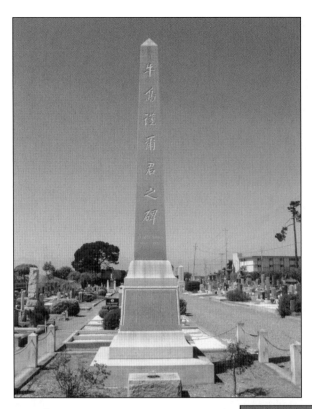

Kinji Ushijima, or George Shima, was an immigrant from Japan who raised potatoes in California. By 1913, Shima had 29,000 acres under cultivation, and he produced about 80 percent of California's potato crop, which earned him the nickname the "Potato King." He died in 1913. (Courtesy of the author.)

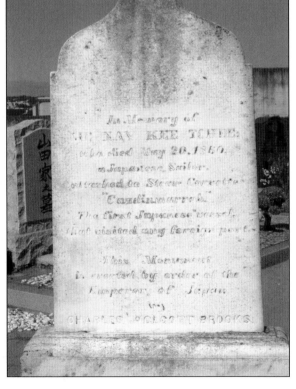

The three oldest monuments in the cemetery, which are barely readable, are in memory of three Japanese sailors who died May 20, 1860. They had been aboard the first Japanese vessel that visited any foreign port. (Courtesy of the author.)

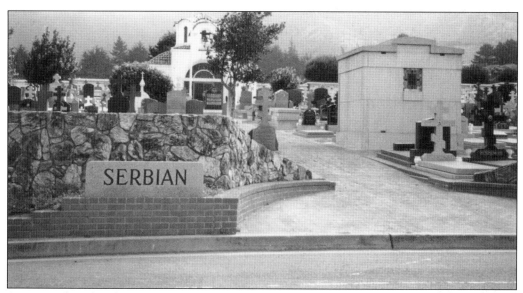

A resting place for Christian Orthodox faiths is the Serbian Cemetery. A mixture of about 10,000 Serbians, Russians, and Greeks are buried on eight acres. The Serbian Benevolent Society was founded in 1880 and originally buried its dead in San Francisco Laurel Hill Cemetery. In 1901, the remains were moved to Colma. There are memorials to Russia's Catherine the Great and the last czar of Russia, Nicholas II. (Courtesy of the Colma Historical Association.)

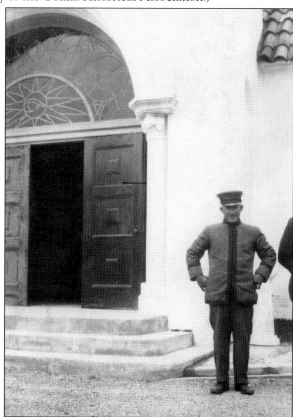

An early manager of the Serbian Cemetery was James Chelone, who is photographed here in his uniform in front of the chapel at the Serbian Cemetery in 1933. (Courtesy of Violet Chelone.)

Pictured from left to right are the Chelone Family: Linda, Inez, Pearl, Violet, and Mildred. Today Violet Chelone Kruljac lives in and manages the Serbian Cemetery. (Courtesy of Violet Chelone.)

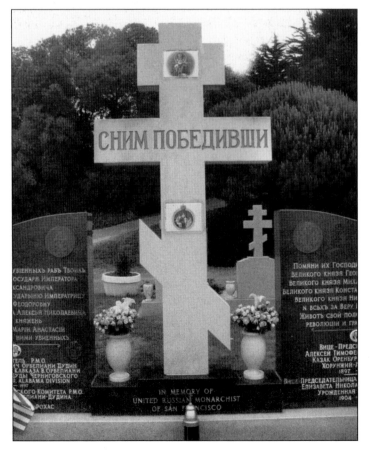

Pictured here is a monument to the last Russian czar, Nicholas II. Born in 1868, Nicholas was a victim of the Bolshevik Revolution. He and his entire family were executed by the revolutionaries in 1918. (Courtesy of the author.)

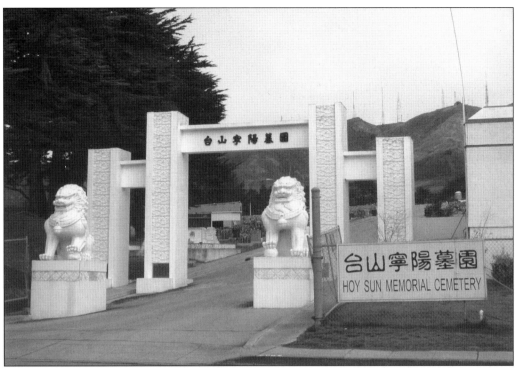

The Hoy Sun Cemetery is one of two Chinese cemeteries in Colma. It opened in 1987. (Courtesy of the author.)

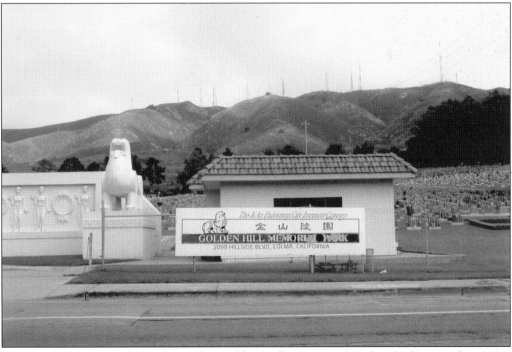

Next to the Hoy Sun Cemetery is the Golden Hills Memorial Park, which opened in 1994. (Courtesy of the author.)

The entrance to Golden Hills is guarded by two large lions to protect the dead. (Courtesy of the author.)

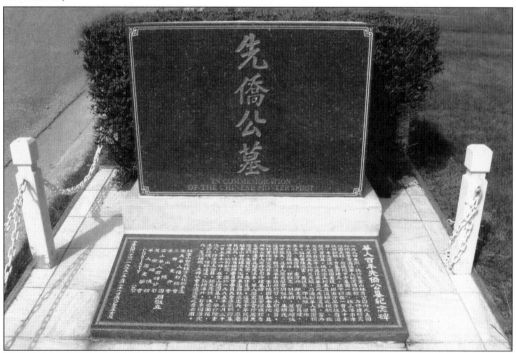

A marker in the Golden Hills Cemetery designates a mass grave for Chinese bodies that were found in 1993 in San Francisco. During earthquake retrofitting of the city's Legion of Honor Museum, graves containing skeletons in redwood caskets were found beneath the museum's courtyard. These burials dated from California's gold-rush era in the 1850s. The remains were turned over to the San Francisco medical examiner, who saw to it that most were reburied in cemeteries in Colma. (Courtesy of the author.)

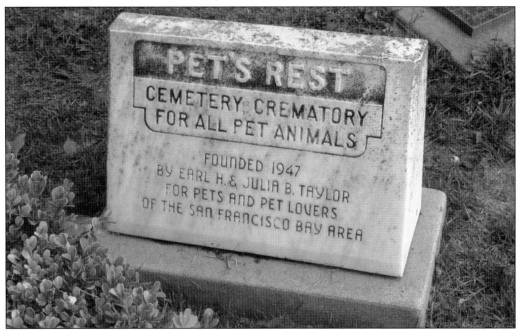

Opened by Julia and Earl Taylor in 1947, this cemetery for animals was called Pet's Rest. It is said that more people visit their deceased animals than their deceased relatives; some say that's because animals give their humans unconditional love. (Courtesy of the author.)

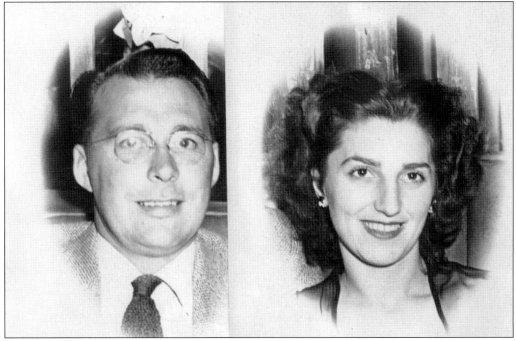

Earl and Julia Taylor are pictured here on their fourth wedding anniversary on September 13, 1947, at Al William's Papagayo Room. Earl was mayor of Colma for four terms between 1956 and 1975. Julia served as an office manager at Cypress Lawn Cemetery and as city treasurer for many years.

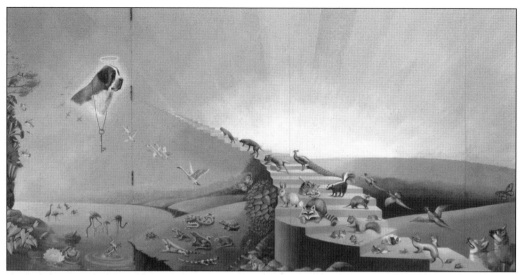

Pictured is one-third of the 7-by-32-foot mural hanging outside Pet's Rest administration offices; it was composed, designed, and painted by Peter Kimack and Roger Rocha. (Courtesy of the author.)

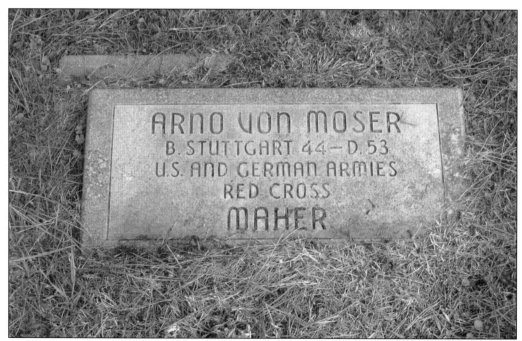

Moser the dog served in World War II. In 1960, for every 2,000 animals buried there was one cremation at Pet's Rest. Those statistics completely reversed by 2006. (Courtesy of the author.)

Sunset View Cemetery, which opened in 1907, is no longer in use. Burials were made from 1907 to 1951, and the records are kept at Olivet Cemetery. It was known as the paupers' cemetery, and today there is no visible trace of the Sunset View. The numbered wooden markers were removed, and parts of the grounds are beneath Cypress Golf Course. (Courtesy of the author.)

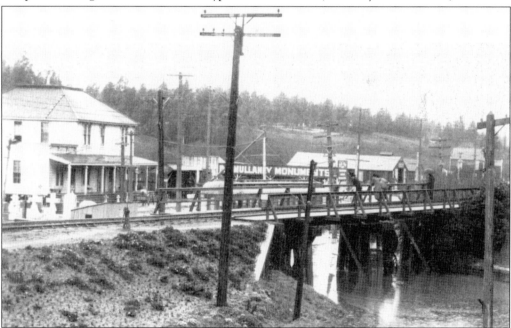

Mullaney Monuments was an early Colma monument company located just north of the Brooksville Hotel, which was a peripheral business to the cemeteries. There have been many stone cutters, such as Italians Valerio Fontana, Leopoldo Bocci, Cavo, and Jim Salacci; Chinese cutter Joe Deng; Irishmen Donohoe and Carroll; Mullaney; Berlin; ACME; and American. (Courtesy of the Colma Historical Association.)

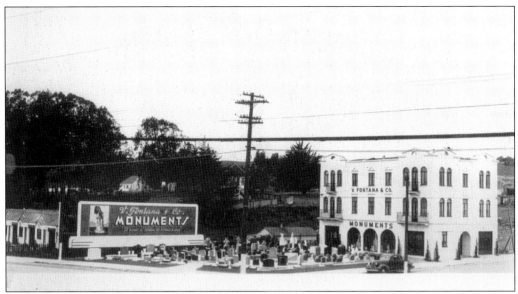

The Fontana and Company Monuments office is on the corner of El Camino and A Street. Italian immigrant Valerio Fontana founded the company. Monuments are made of granite and marble. Marble is a soft stone usually used for statuary. Without proper protection, workers can contract silicoses from granite, which is what Fontana died from at the age of 71. Fontana is buried in the Italian Cemetery. (Courtesy of Eulio Fontana.)

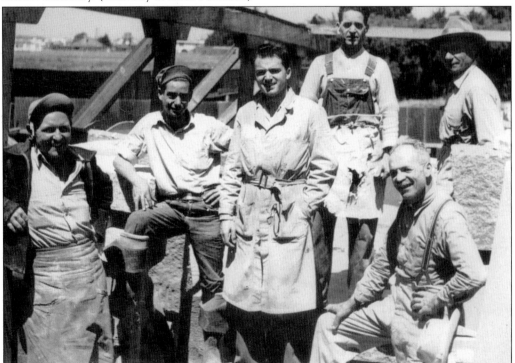

Pictured here from left to right in 1947 is the Fontana and Company Monuments crew of Joe Klackner, Carlo Innocenti, Elio Fontana (hand in pocket), Guiseppe DelCarlo, Valerio Fontana (suspenders), and Fausto Favero. (Courtesy of Eulio Fontana.)

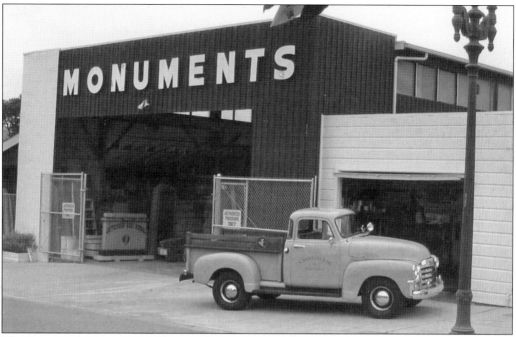

The Fontana factory, pictured here with a company delivery truck, stands on the corner of F and Clark Streets. (Courtesy of the author.)

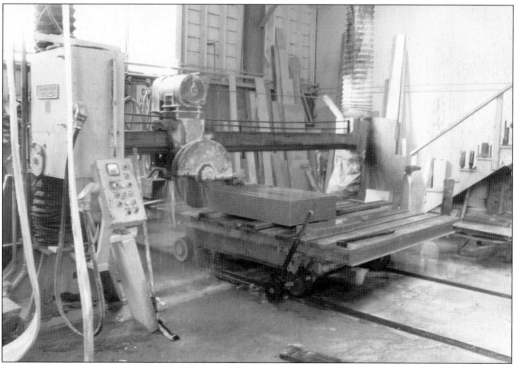

Inside the Fontana's factory, workers cut stones from slabs. Stones come from many places, including California, Minnesota, Sweden, England, Russia, Taiwan, and China. In the early part of the 20th century, monument stones were often transported as ballast in ships. (Courtesy of the author.)

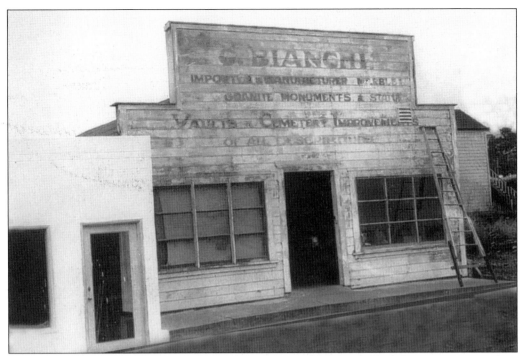

The Bianchi Monument Company, located on the corner of F and Clark Streets, was next door to the Fontana Monument Factory. The Bianchi building was torn down in 1950. On the left is the old Ottoboni flower shop. (Courtesy of the Colma Historical Association.)

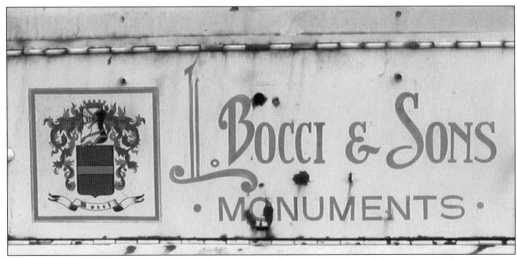

Here is the crest on an old generator of L. (Leopoldo) Bocci and Sons Monuments. The company was another well-known monument maker that began in Colma in 1906. Like many of the cemeteries, Bocci began his business in San Francisco before moving to Colma. Leopolo Bocci is buried in the Italian Cemetery. (Courtesy of the author.)

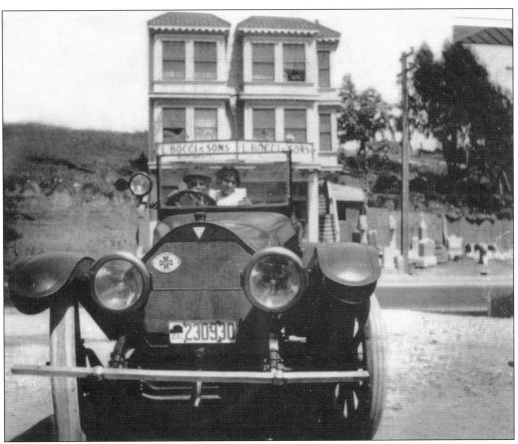

Jennie and Tom Bocci ride in their old car on El Camino and F Street in 1916. The company is now closed. (Courtesy of Colma Historical Association.)

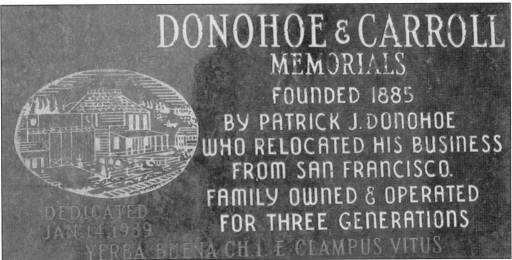

Donohoe and Carroll is the oldest continuous monument maker in Colma and has been in business since 1885. The business has survived so long because of its location—across the street from Holy Cross Cemetery—and because of good management. (Courtesy of the author.)

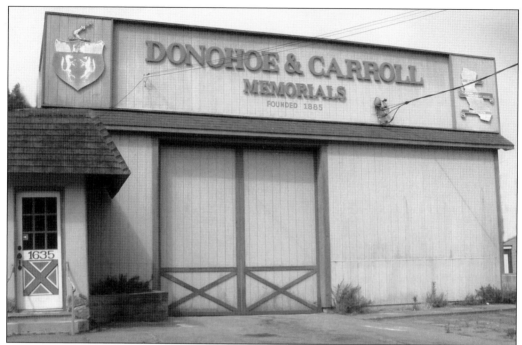

The old office and factory are no longer in use. The new offices of Donohoe and Carroll are about a quarter-mile south of this location, where Patrick Donohoe's grandson Jack manages the business. Jack says that the monument business has been slower since the year 2000 because there are fewer craftsmen, more work is done with computers, and too many monument companies competing for less work. (Courtesy of the author.)

Joe Deng poses with an example of his work, a 75-ton Chinese monument. Deng is the owner and master artisan of the Golden Hill Monument Corporation. This monument was built for the Wong family, and Deng engraves all the monuments by hand. Fifty percent of the bare granite he uses comes from China. (Courtesy of Joe Deng.)

Three

LAWNDALE
1924–1941

By 1924, the owners of cemeteries located in unincorporated Colma decided to incorporate to protect their cemeteries. The owners were worried, and they had good reason. San Francisco had evicted them because their city land was too valuable to use for cemeteries, and they had watched new cities incorporate from within their unincorporated land and did not want to be evicted again. So they voted for incorporation and called their new town Lawndale. The town was a short chapter in Colma's history, lasting a mere 17 years.

Though called Lawndale, most residents continued to use the term Colma for the area. Most of Colma's traditional business districts had been absorbed by Daly City when it was incorporated in 1911. Following incorporation of Lawndale, there still remained an area called unincorporated Colma.

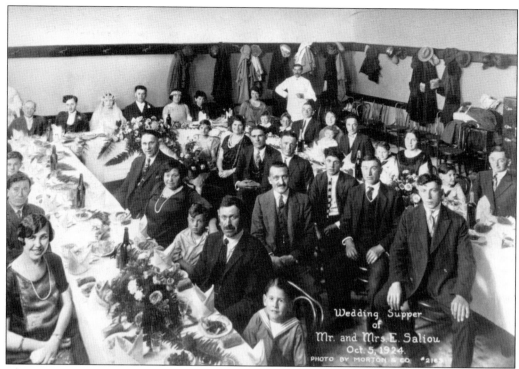

This is the wedding supper of Angelina Ed Salliou in 1924. The bride, the former Angelina Olcese, is sitting in the back. Angelina was the daughter of a pioneer Colma family. Pictured at the head table are Francesco and Maria Olcese, whose parents had emigrated from Genoa, Italy, to Colma before 1900. (Courtesy of Marilyn Olcese.)

This is the Colma Pharmacy calendar from January 1923. (Courtesy of the Colma Historical Association.)

The Anchor Drugs store on Mission and Market Streets is seen here in 1929. (Courtesy of the estate of Emma Ver-Linden.)

This is a sign identifying the town of Lawndale on Mission Street. (Courtesy of the Colma Historical Association.)

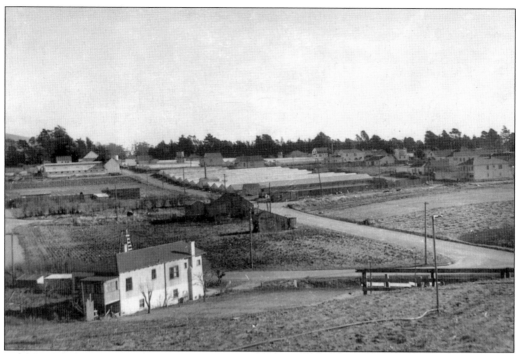

Seen here are the greenhouses of the Abbey Street Nursery (1924–1952), formerly D. Caserza and Brothers, located at Abbey and Chester Streets. (Courtesy of the Ratto family.)

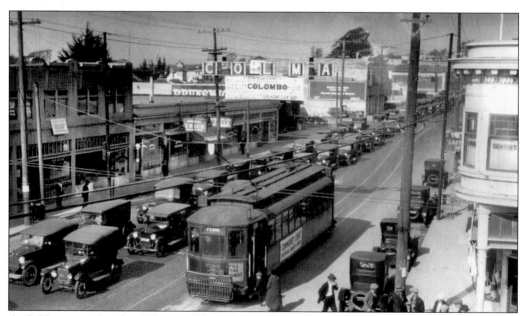

At 2:00 p.m. on Sunday, February 15, 1925, a traffic jam took place in Colma on Market Street due to a funeral procession. (Courtesy of Marylin Olcese.)

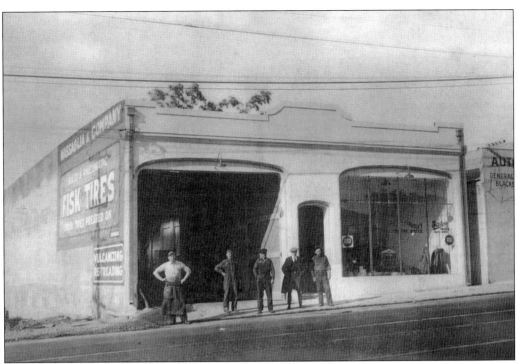

Here is the Massaglia place of business. The building to the right is the Peter Benassini Blacksmith Shop. The men standing in front, in no particular order, are the blacksmith, the wagon-truck mechanic, the body builder, the auto-truck mechanic, and the office manager and owner, Michael J. Massaglia. (Courtesy of the Colma Historical Association.)

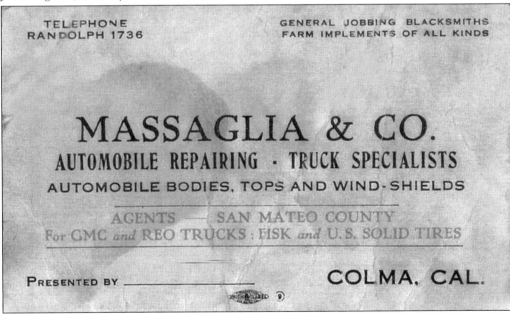

This is the business card for Massaglia and Company. The company was started in 1920 and specialized in repairing automobiles and trucks, as well as in selling farm implements. (Courtesy of the Colma Historical Association.)

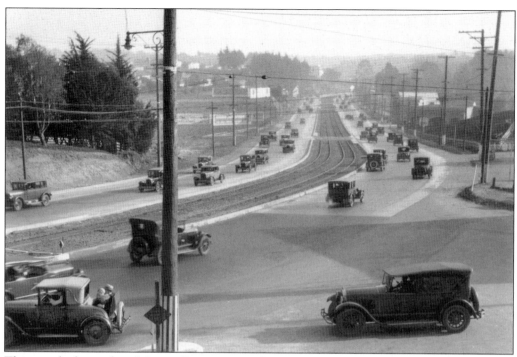

This view looks south on Mission Street in 1927. (Courtesy of the Colma Historical Association.)

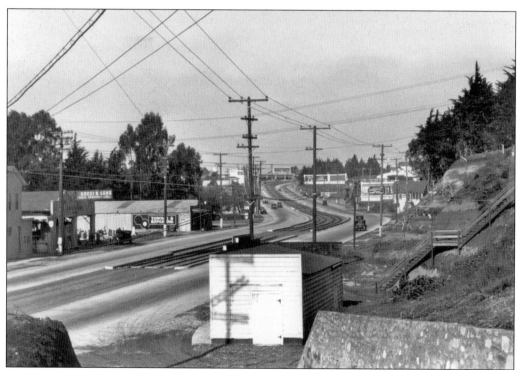

Pictured here is El Camino looking northwest from F Street around 1926. Bocci Monuments is on the left. (Courtesy of the Colma Historical Association.)

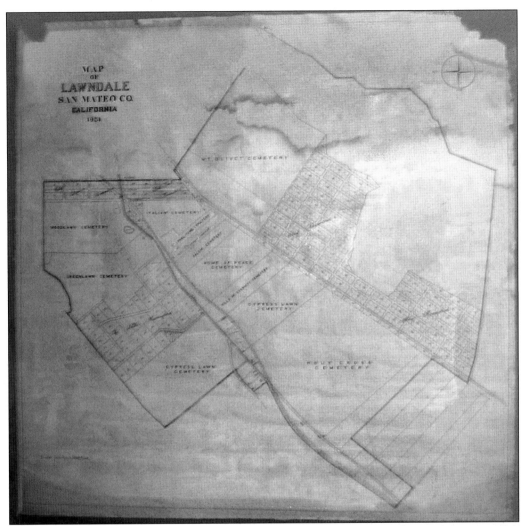

This image shows a map of Lawndale found in Charlie Scrabian's gas station on the corner of A Street and Hillside Boulevard. (Courtesy of the Colma Historical Association.)

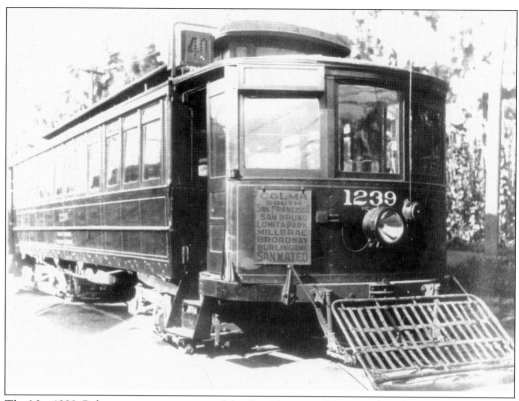

The No. 1239 Colma streetcar was part of the San Francisco Municipal Railway that operated in San Mateo County from 1903 until 1949. (Courtesy of the Colma Historical Association.)

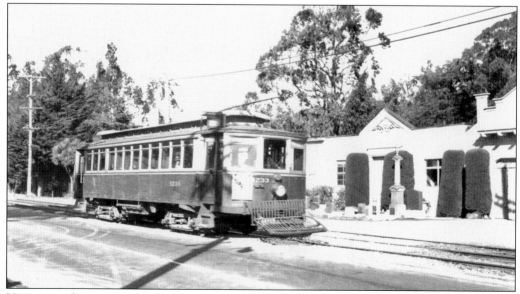

Here is another streetcar in Colma on the county road between Cypress Lawn and Holy Cross cemeteries. (Courtesy of the Colma Historical Association.)

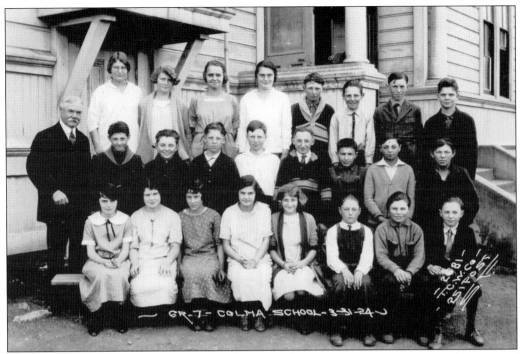

A seventh-grade class poses at Colma School on March 31, 1924. (Courtesy of the estate of Emma Ver-Linden.)

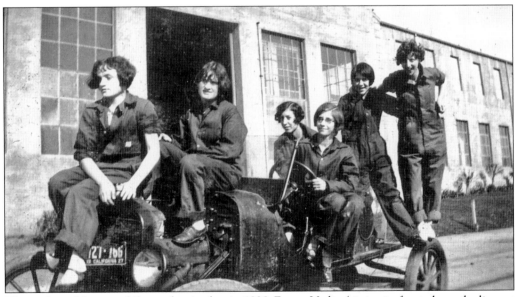

This is the girls' automobile-mechanic class in 1928. Emma Verlin (sitting in front above the license plate) is pictured here with her classmates at Jefferson High School. (Courtesy of the estate of Emma Ver-Linden.)

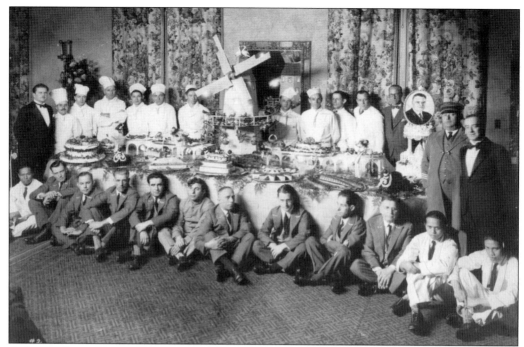

A festive dinner party celebrates the election of Pres. Herbert Hoover on December 22, 1928. The portrait of Hoover on the right is made of chocolate. The man sitting on the floor below the windmill is Antonio Garibaldi, a Colma waiter. (Courtesy of the History Guild of Daly City/Colma.)

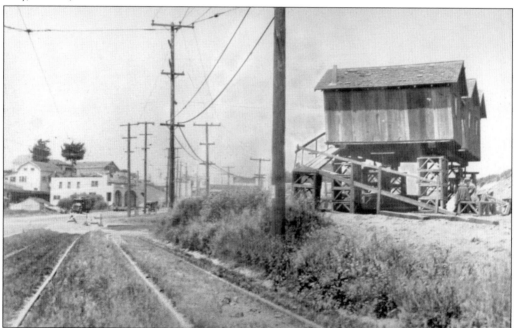

"Mother" Minerva Hartman's house was raised up to make room for the widening of Mission Street. Hartman was a colorful Colma resident said to be a soothsayer and a nurse from the Spanish-American War. (Courtesy of the Colma Historical Association.)

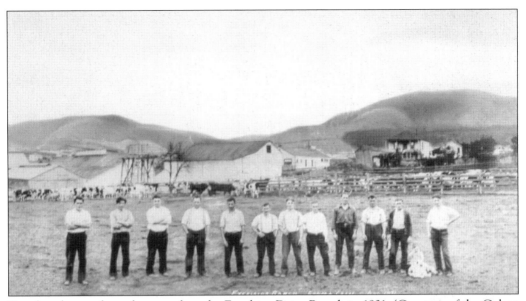

Farmhands pose for a photograph at the Excelsior Dairy Ranch in 1931. (Courtesy of the Colma Historical Association.)

This is the Excelsior Dairy Ranch delivery truck in 1926. (Courtesy of the estate of Emma Ver-Linden.)

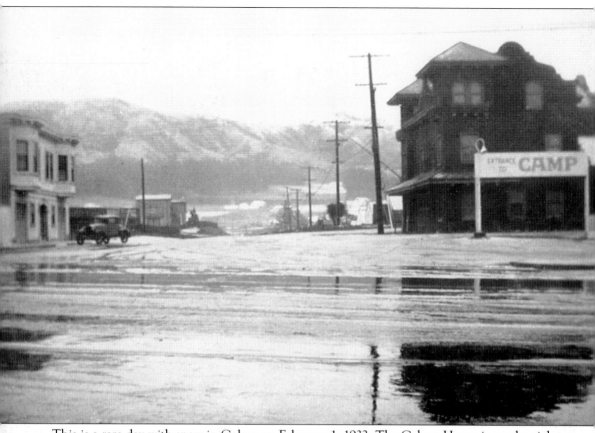

This is a rare day with snow in Colma on February 1, 1932. The Calopy House is on the right, where in 2006 a Wendy's stands. (Courtesy of the estate of Emma Ver-Linden.)

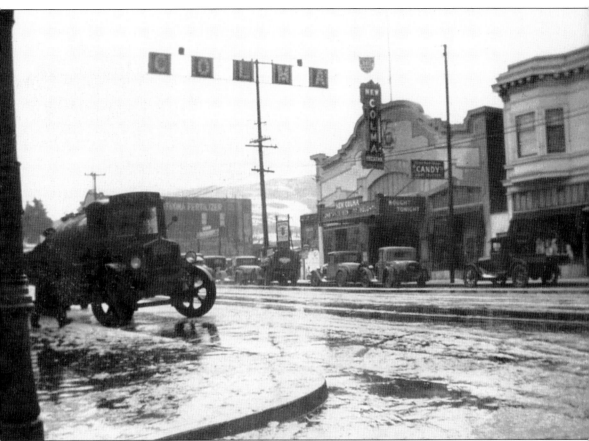

The New Colma Theater in 1932 was located on Mission Street. The theater was a 100-seat show house offering nightly silent films and a cartoon. On weekends, there were vaudeville acts as well. Today the building is home to the Globe Tavern. (Courtesy of the estate of Emma Ver-Linden.)

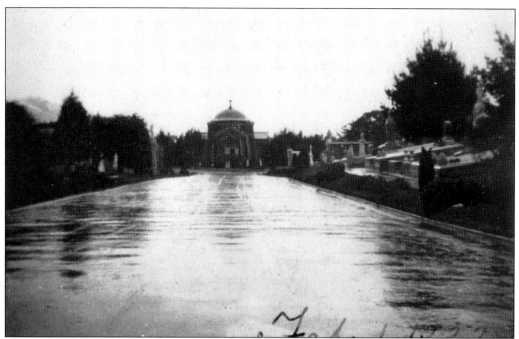

Snow blankets Holy Cross Cemetery on February 1, 1932. (Courtesy of the estate of Emma Ver-Linden.)

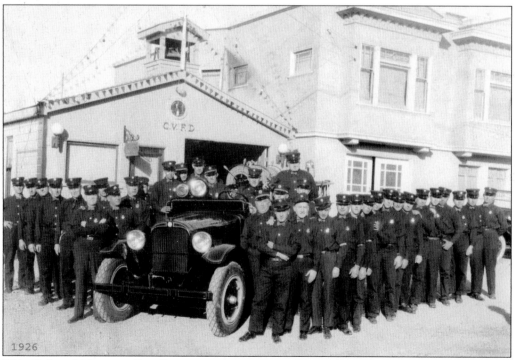

The Colma Volunteer Fire Department stands at the ready in 1925. (Courtesy of Chief George Riccomi.)

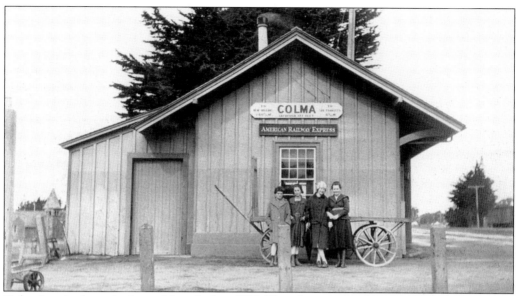

Colma's train depot is pictured here before 1925. The white sign reads, "To New Orleans 2471 . . . M . . . COLMA . . . Elevation 177 Feet . . . To San Francisco 8 . . . M." Below that sign, another reads, "American Railway Express." (Courtesy of the estate of Emma Ver-Linden.)

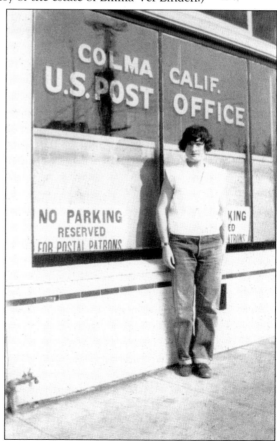

Postmistress Emma Ver-Linden stands in front of the Colma Post Office in 1928. (Courtesy of the estate of Emma Ver-Linden.)

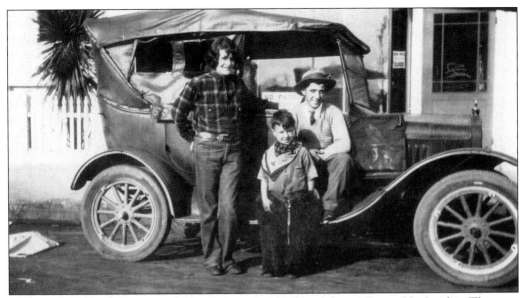

Standing in front of the Colma Post Office in the checkered shirt is Emma Ver-Linden. This post office was located west of the Belli Building on San Pedro Road. Today the building is gone, and in its space is the parking lot for Walgreens. (Courtesy of the estate of Emma Ver-Linden.)

ALPERT MEAT CO.

PROGRESS HOG CO.

DOMENIC OLCESE

JOHN OLCESE

OLCESE BROS. HOG CO.

THOMAS CALLAN & SONS CO. . .

STANDARD HOG CO.

NEW COLMA HOG CO.

AMERICAN HOG CO.

SAN FRANCISCO HOG CO.

GEO. LAGOMARSINO CO.

GREEN VALLEY HOG CO. . . .

CENTRAL HOG CO.

SANITARY HOG CO.

NEW CALIFORNIA HOG CO. . . .

CRESTA HOG CO.

A. DEL GRANDE

CORTOPASSI CO.

A. BOTTI & SONS

STAR HOG CO.

Hog farming in Colma was a thriving industry for about 75 years. The demand for ham and bacon, cheap food for hogs, and the Western Meat Company in South San Francisco all helped support hog farmers in Colma. Every farm raised a few hogs, but some raised thousands. Hog farming continued until the stench and flies became too much for Colma residents. By about 1968, hog farming had come to an end in Colma. This is a select list of Colma hog farms in the Holy Angels Church program of 1943. (Courtesy of the Colma Historical Association.)

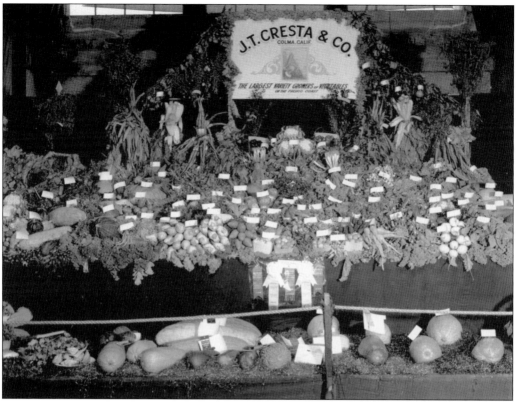

This is a Cresta Farms display. Located on Hillside Boulevard, this hog ranch lasted until 1968 and was the last one in Colma. Tillio Olcese and Sons ran it. (Courtesy of Ratto family.)

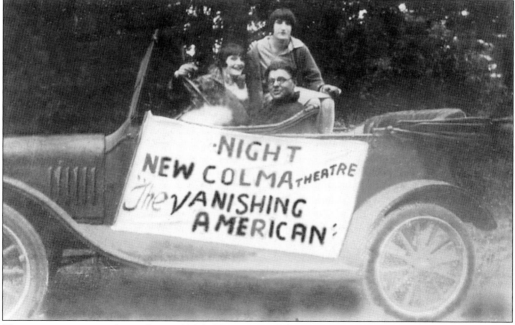

Here is a promotion for a play in 1926. (Courtesy of the estate of Emma Ver-Linden.)

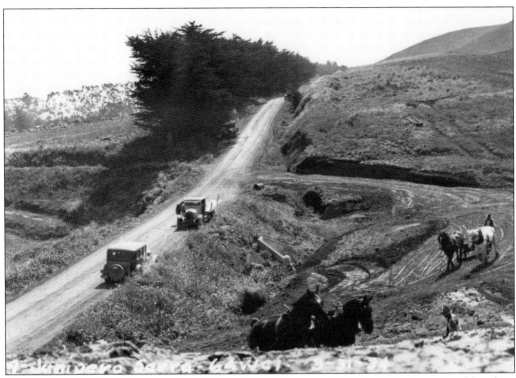

This is Junipero Serra Boulevard and Woodlawn Cemetery (left) in 1934. Serra Bowl bowling alley and a rapid-transit station occupy this area in 2006. (Courtesy of the History Guild of Daly City/Colma.)

A third-grade class poses for the camera at Robert S. Thornton Elementary School in 1939. (Courtesy of Jim Salacci.)

Four

COLMA
1941–2006

As the town of Lawndale and the country was about to enter World War II, the U.S. Post Office notified the residents of Lawndale that their town name had to be changed because there was another Lawndale in Southern California. Thus the town of Lawndale officially changed its name in 1941 to Colma. It is interesting to note that the other Lawndale in Southern California was not incorporated until 1959.

Since 1941, there has been both an incorporated town and an unincorporated area of Colma. Efforts to consolidate these areas have been thwarted by local politics.

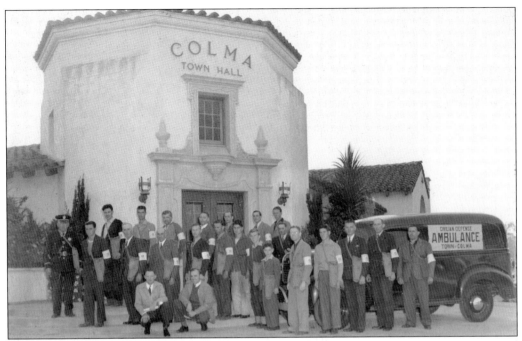

Members of the civilian-defense council of the town of Colma stand in front of city hall. Pictured from left to right are the following: (kneeling) John Price and Bradford Welch; (standing in front of the ambulance) William Dobko and Jack McCaffery; (standing by the ambulance) Fred DeMartini, Vincent Barsi, Samuel McCaffery, John Newton, and Ray Ottoboni; (first row, back) Leo Scramalgia, Volney Muzzy, Peter Barsi, John Dobko, Eugene Baciocco, Aldo Lanza, and Victor Drago; (second row, back) chief of police Joe Cavalli, James Demattei, Elbi Lanza, Lewis Richard, Jay Jensen, Albert Edler, Russell Antracoli, and Louis Drago. (Courtesy of Chief George Riccomi.)

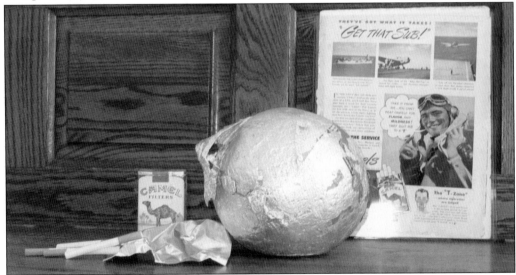

A 40-pound ball of tin foil, made from many cigarette packs, was saved by Stanley Goodrick, the father of Pat Hatfield, from 1941 to 1946 to help fill the metal shortage during World War II. The ball was not turned in when the war ended.

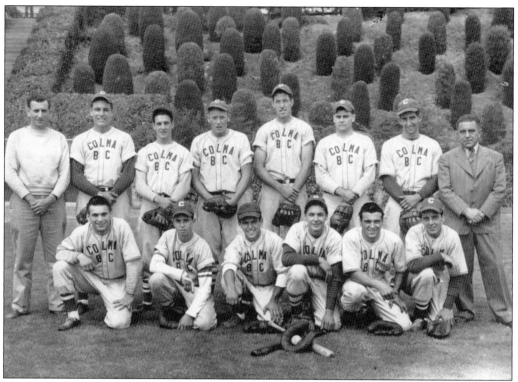

The Colma Boys Club (BC) players, coach, and their sponsor are seen above at Marchbanks Park in 1948. Pictured, from left to right, are the following: (first row) George Perata, Leland Michelleti, Don Lunghi, John Olcese, Rico Ottonello, and Jim Salacci; (second row) coach Mossi Sr., Tinto Sarto, Ben Paradi, Don Wohl, Howard Hefferson, Al Lagomarsino, Don Mossi, and Joe Sarto. The Catholic Youth Organization (CYO) baseball team, the Colma BC, was sponsored by Joe Sarto. He owned the Villa Sanitarium hospital in Colma. Don Mossi went on to pitch in the major leagues from 1949 to 1965 for the Cleveland Indians. Mossi lives in Idaho today. Jim Salacci is from Bocci Monuments. The team played together for about six years. Pictured at right is the Colma BC team championship patch from 1948. (Above courtesy of Esther Ottonello; right courtesy of Jim Salacci.)

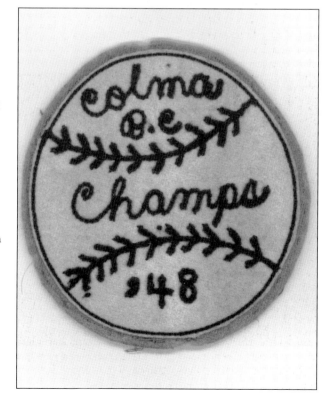

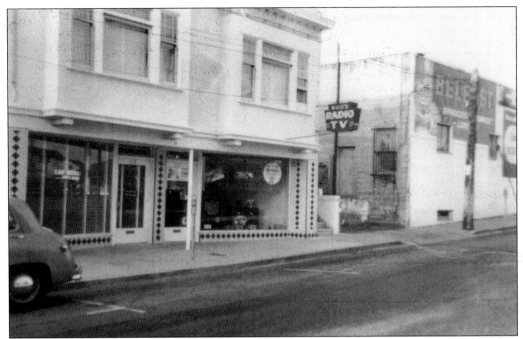

This is Bud's Radio and TV in 1953. The storefront at left was the law office of Harry Baier and the Colma Hog Raisers Association. The building at right is the back of the Anchor Drug Company. (Courtesy of the History Guild of Daly City/Colma.)

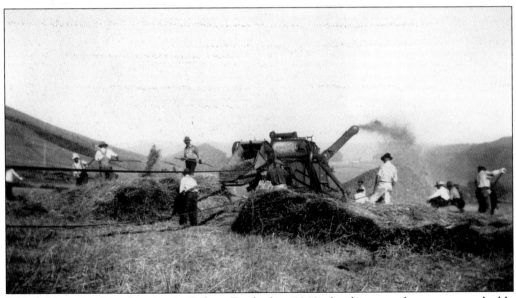

Pictured here is wheat farming in Colma. By the late 1940s, land in town became too valuable to farm. Post–World War II years brought boundary adjustments, new housing, shopping centers, automobile dealerships on Serramonte Boulevard, a police department, and a card club. Cemetery owners ended farm leases, and privately owned farms sold or leased their land to developers. (Courtesy of the estate of Emma Ver-Linden.)

This is the Colombo Box Company in 1950. Several box-manufacturing plants were built along the railroad tracks through Colma. (Courtesy of the Colma Historical Association.)

Here is the Chesterfield Box Company. Other box companies included California Vegetable Union Box, A. Marchetti Vegetable Packing House, American Box and Drum Company, H. P. Garin Produce Company, and the Biggio Packing House. (Courtesy of the Colma Historical Association.)

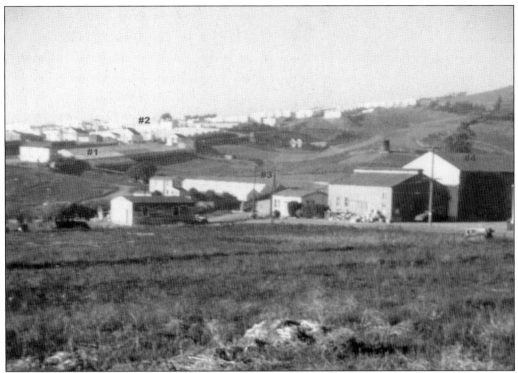

Seen here in 1952 is farmland that eventually gave way to housing developments. The numbers represent what was still there that year: (No. 1) Leveroni Nursery (No. 2) Picetti Nursery, (No. 3) Michelitti Nursery, and (No. 4) Witts' Dairy. (Courtesy of Ratto family.)

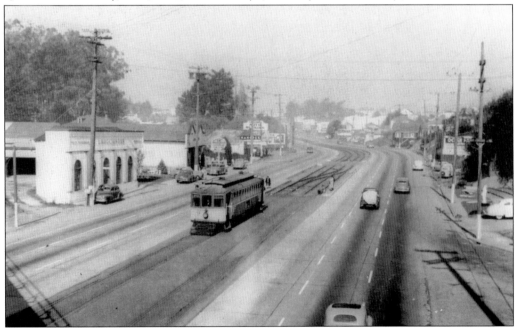

This picture looks north from the railroad bridge over Mission Street in 1948. Streetcars or trolley cars on Mission were soon to disappear. (Courtesy of the Tom Gray Collection.)

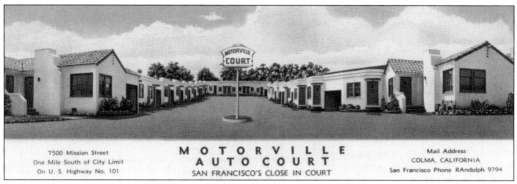

Here is the Motorville Auto Court on Mission Street in Colma. The emergence of motels catered to people with automobiles. (Courtesy of the Colma Historical Association.)

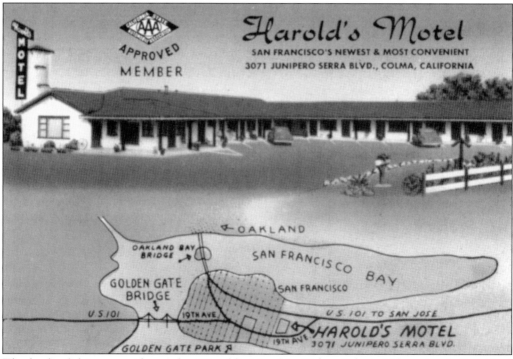

The back of this postcard says that Harold's Motel in Colma featured "luxuriously furnished apartments, all tile showers, rubber foam mattresses, radio and TV in all units." (Courtesy of the Colma Historical Association.)

According to the back of this postcard, Millet's Auto Court featured "every accommodation for the Discriminating Guest." It was also the former site for Millet's Training Center for boxing. (Courtesy of the Colma Historical Association.)

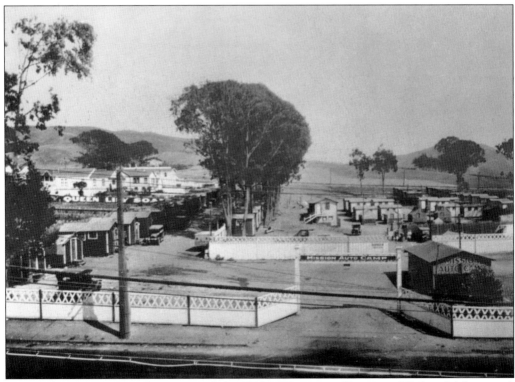

Here is the Mission Auto Court around the 1920s. (Courtesy of James and Robert McLennan.)

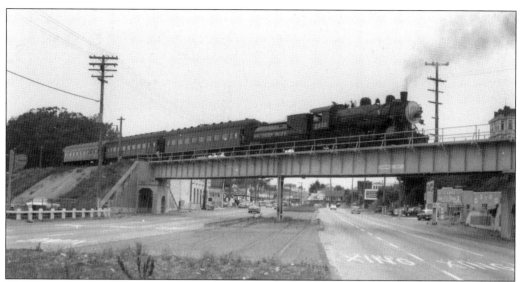

A Southern Pacific train on the F Street overpass crosses above Mission Street in 1956. Freight train service through Colma ended in 1978. (Courtesy of the Colma Historical Association.)

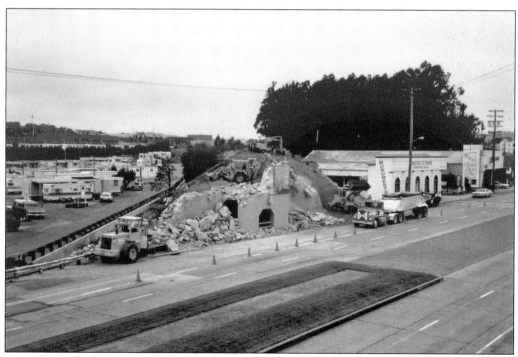

In 1992, the Southern Pacific overpass was demolished. The Bay Area Rapid Transit (BART) district purchased the old Southern Pacific Railway right-of-way through Colma for their new system. (Courtesy of the Colma Historical Association.)

A NEW DESIGN FOR BART CARS

Here is a BART car in 1995. (Courtesy of the Colma Historical Association.)

The Southern Pacific overpass was replaced with an overpass for BART that began service through Colma in 1996. A coalition of cemeteries stipulated that the new transit system would be covered or underground through Colma. (Courtesy of the Colma Historical Association.)

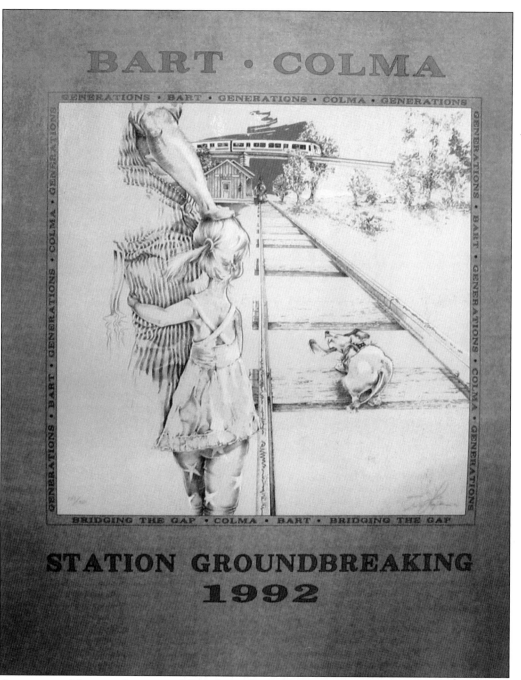

A poster celebrates the ground breaking for BART in 1992. (Courtesy of the Colma Historical Association.)

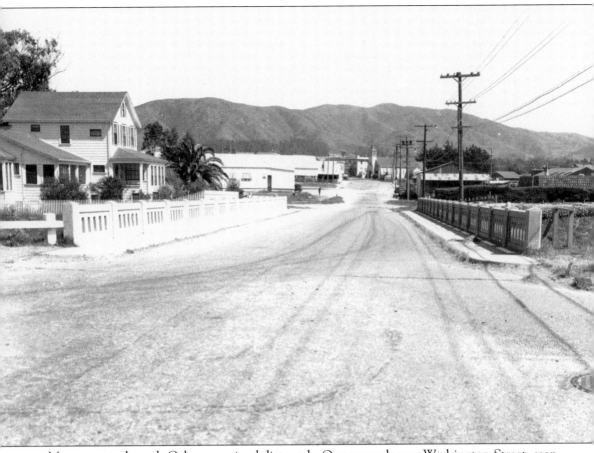

Many streets through Colma remained dirt roads. One example was Washington Street, seen here looking east with Mrs. Brown's house on the left and Holy Angel Church in the distance in the foreground of San Bruno Mountain. Today Washington Street is paved, and the bridge spans Interstate Highway 280. (Courtesy of the History Guild of Daly City/Colma.)

ANNUAL PICNIC
—OF—
HOLY ANGELS' PARISH
Labor Day, 1923
LOVCHEN GARDEN, COLMA, CAL.

A WORD OF THANKS—On behalf of the members of The Parish I wish to thank all those who, by their patronage and donations helped to make this Festival a success. Kindly preserve this program and look over the advertisers and donors. They have been generous in their assistance and have extended every courtesy when called upon.

REV. C. J. BERTOLA, Rector.

This is the 1923 bulletin of Holy Angels' Parish. Originally it was called St. Anne's Church in honor of Anne Dunks. The church was built about 1868 and today is known as Holy Angels Church. (Courtesy of the Colma Historical Association.)

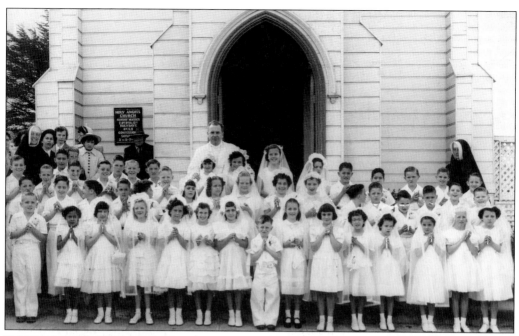

Pictured here is communion in 1951 with Pastor Anthony M. Morrissey. (Courtesy of Tillio Olcese II.)

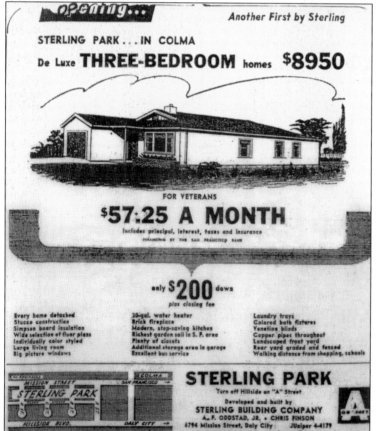

A new housing development called Sterling Park was built with funds from the GI Bill. Much of the Rosaia farmland was sold to construct this residential area. The model home was on the 400 block of C Street. (Courtesy of the Colma Historical Association.)

Two of the original residents of Sterling Park were Lee Marsigli and his wife, Jean, pictured here in front of their home in June 1966. (Courtesy of Lee Marsigli.)

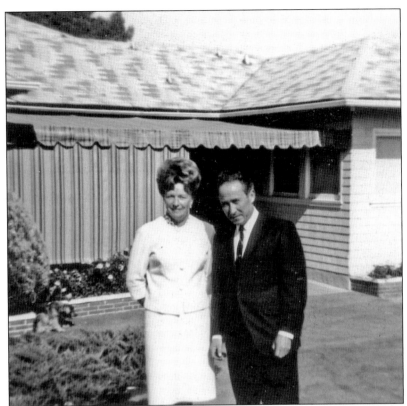

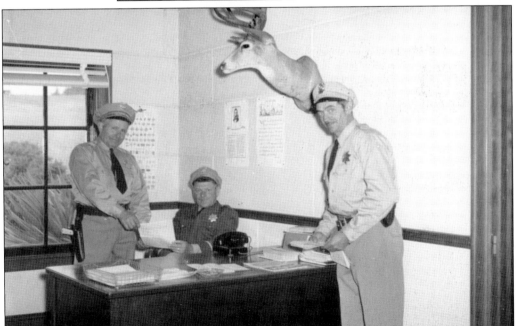

Here is the three-man Colma Police Department in 1954. Pictured from left to right are Ray D. Ottoboni, police chief Albert "Dino" Lagomarsino, and officer John Vallerga. (Courtesy of the Colma Historical Association.)

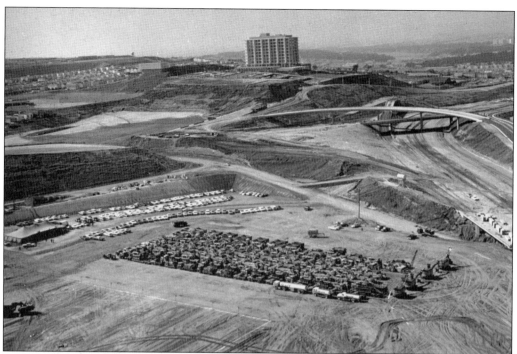

One of the first new shopping centers to be built was Serramonte Plaza, which was begun in 1967. (Courtesy of the History Guild of Daly City/Colma.)

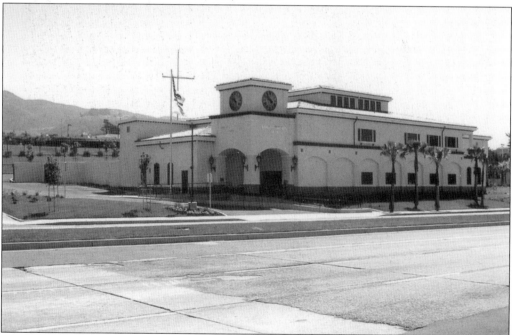

The new police station sits on the east side of Mission Street and across the street from city hall. With the construction of several new shopping centers in Colma, two or three officers could no longer handle law enforcement in Colma. So in 1974, a full-fledged police department was formed.

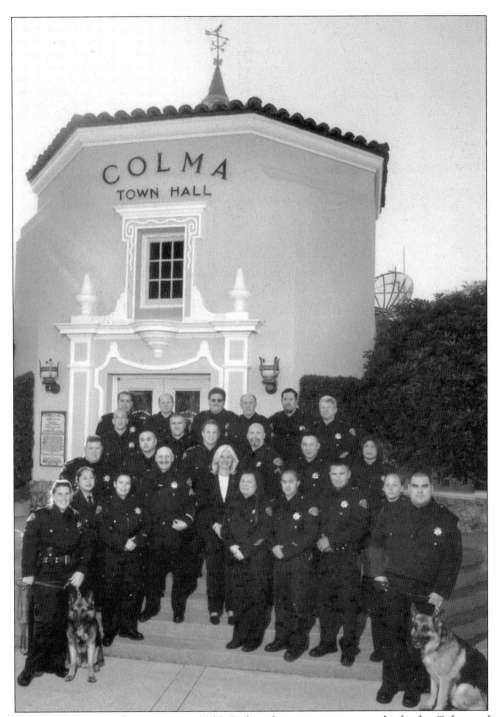

Here is Colma's police department in 2005. Before their new station was built, the Colma police shared the space in the old town hall. Colma's crime rate rises at the end of each year when its population of 1,500 swells from to 40,000 to 70,000 because of Christmas shoppers taking advantage of Colma's shopping centers and the Serramonte Road row of car dealerships. (Courtesy of the Colma Police Department.)

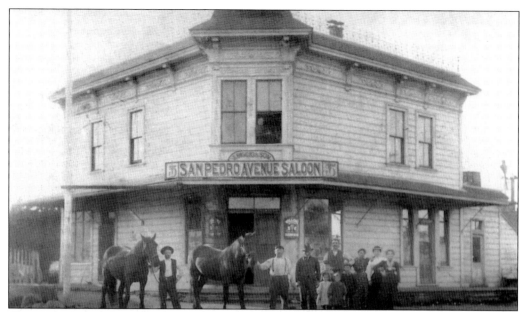

This is the San Pedro Avenue Saloon, owned by J. Biggio and Son. Faintly seen on the roof is a railing called the widow's walk. The saloon was located on the corner of San Pedro Road and Reiner Street. Since the early 1920s, Colma was known for its nightclubs, some which featured gambling, strip joints, bars, and restaurants. Three of these popular places included the San Pedro Saloon, the Willow, and Lovchen Gardens. (Courtesy of the Colma Historical Association.)

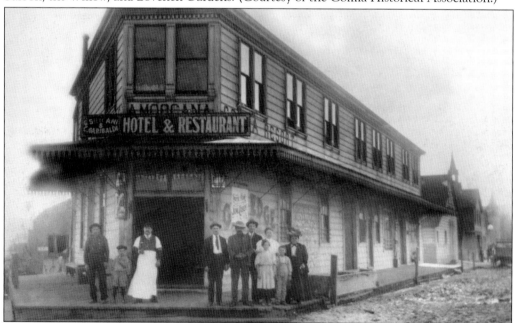

At one time, this building was a hotel and restaurant owned by C. Garibaldi. Later it would be called the San Pedro Lunch and was owned by Carlo Agresti. Pictured here, from left to right, are ? Franzoia, David Arata, ? Barsuglia, Leo Graziani, unidentified, C. Garibaldi, Angelo Moresco, Jennie Moresco, Josie Moresco, and Maria Armanino. (Courtesy of the Colma Historical Association.)

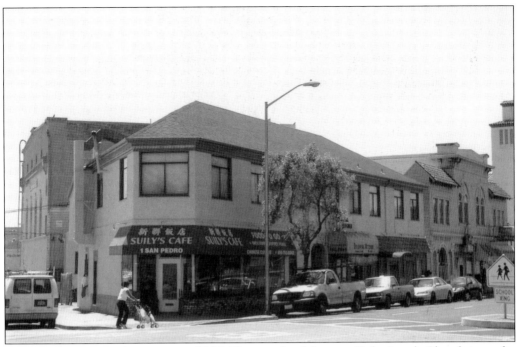

Suily's Café occupies this corner in 2006. The steeple of the new Holy Angels Church is on the far right. (Courtesy of the Colma Historical Association.)

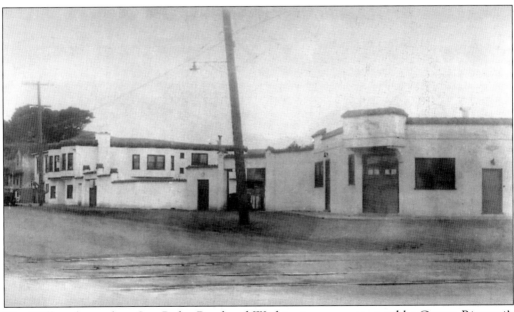

The Willow, located on San Pedro Road and Washington, was managed by George Riccomi's grandfather from about 1930 to 1958. (Courtesy of Chief George Riccomi.)

Behind the Rosaia Ranch was the Lovchen Gardens. On the corner of Hillside Boulevard, Chester Street, and Linden Street, Lovchen Gardens has featured over the years a bar, restaurant, dance hall, and a bowling alley. The gardens were also known as a "smoker," which was a very risqué hangout. (Courtesy of Shirley Michelleti.)

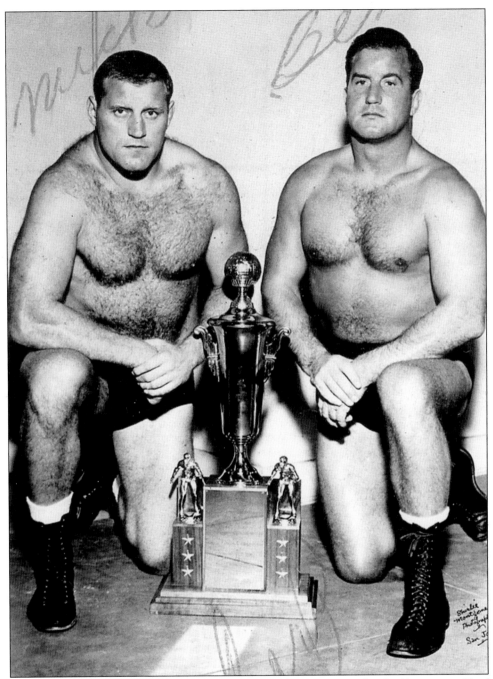

The new owners of Lovchen Gardens, Mike and Benie Sharpe, renamed it the Copperwood Lodge. From the late 1950s to around 1964, Mike and Bernie Sharpe were a tag-team wrestling duo known from the Bay Area to Japan. Mike Sharpe lived on the corner of B Street and Clark Street. Lee Marsigli's daughter Barbara often was the babysitter for Mike. Following the Copperwood Lodge, there were more name changes, including Castegnettos, Mr. G's Steakhouse, Mr. G's Rockhouse, Vincenzo's (featuring live bands and polka music), Casa Manila, Los Juanas, and La Pachanga. (Courtesy of Richard Rocchetta.)

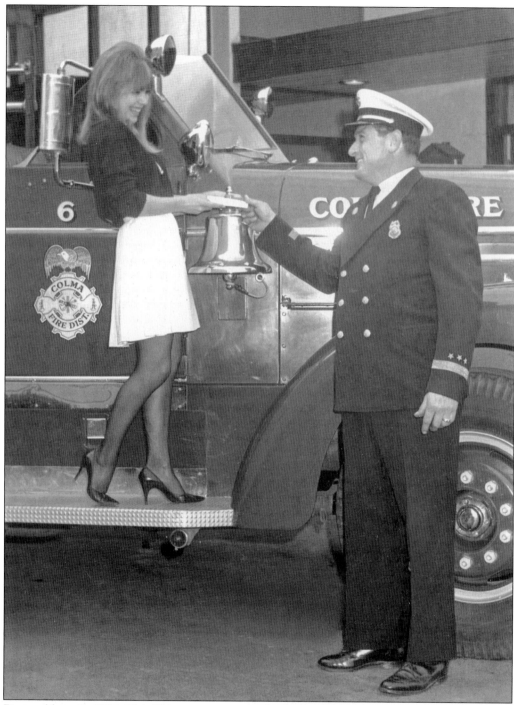

Pictured here in 1976, Chief Riccomi accepts a check at a fund-raiser for the department from Playboy Bunny Julie. Though still a volunteer service, the Colma Fire Department is a pay-per-call operation in 2006. (Courtesy of Chief Riccomi.)

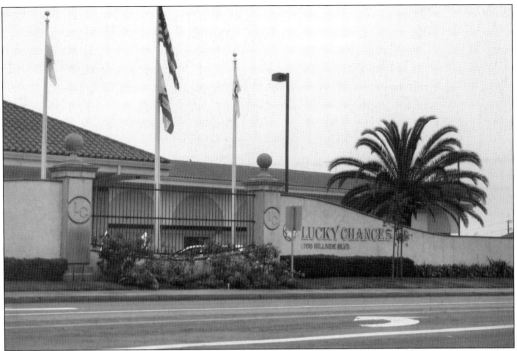

The Lucky Chances card club, on the corner of Hillside and Serramonte Boulevards, opened in 1995. Lucky Chances is the only card club in Colma.

The La Terrazza at Colma Station (BART) apartment building today stands on the site of the old Colma Hotel. (Courtesy of the Colma Historical Association.)

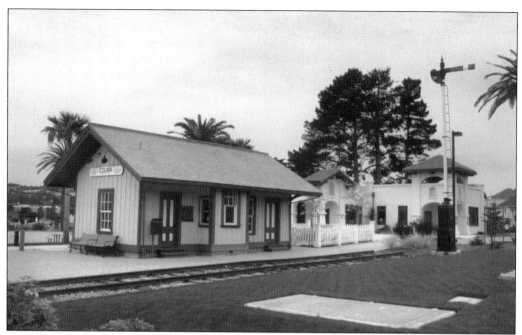

What was once the Olivet Cemetery administration building on the right is now the home of the Colma Historical Museum. The 1863 train depot on the left was moved to this new location in 2003.

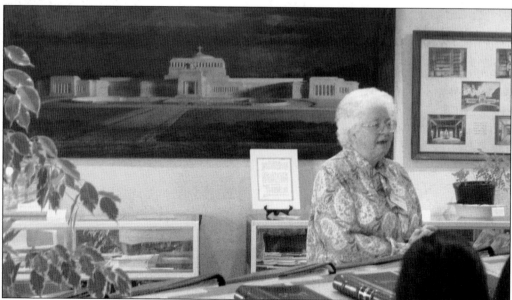

Standing in the Cemetery Room of Colma's History Museum before a painting of the first conception of what Holy Cross's mausoleum should look like is museum director Pat Hatfield. Hatfield is a very dedicated curator who seeks to preserve and protect Colma's history. Besides the Cemetery Room, there is the Kitchen Room, with contents from the year 1924 (the year Colma incorporated); a library including a video about Colma; a room dedicated to Colma's volunteer firemen; and an area for Colma's police. In addition to the main musuem, there is a replica blacksmith shop and the original freight station and train depot.

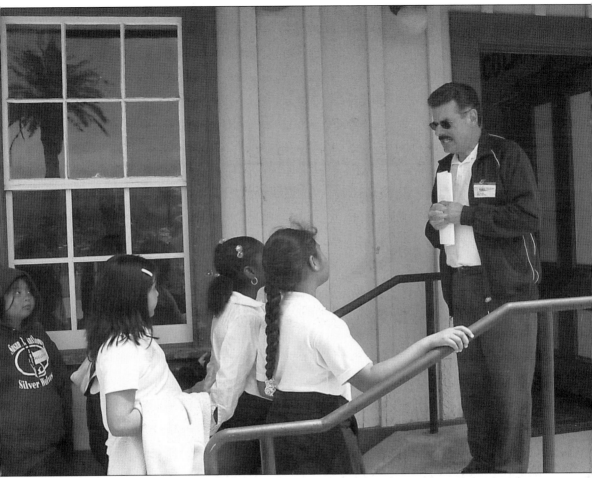

Volunteer docent Richard Rocchetta relates a chapter of Colma's history to a class of students on a field trip to the Colma museum.

This is Richard Rocchetta's Colma ancestry. Pictured from left to right are son Joe, father Giovanni, mother Dorthea, son Bacci, and daughter Rose Rocchetta. Giovanni worked on the Violet Rosaia Ranch, and Bacci worked at Olivet Cemetery. (Courtesy of the Colma Historical Association.)

PICTURE OF ROCCHETTA FAMIL
(1917) LEFT TO RIGHT-
JOE ROCCHETTA, GIOVANNI
ROCCHETTA, DORTHEA ROCCHET
BACCI ROCCHETTA & LITTLE

Getting into character to enhance the historical tour of the museum for a school tour of Colma's historic train station is docent Ron Doyle, dressed as Wyatt Earp. After the famous marshal left Tombstone Territory in the early 1880s, he traveled throughout the West. In the 1890s, Earp worked as a boxing referee in San Francisco. At the time, he may have visited Millet's Boxing Training Center in Colma.

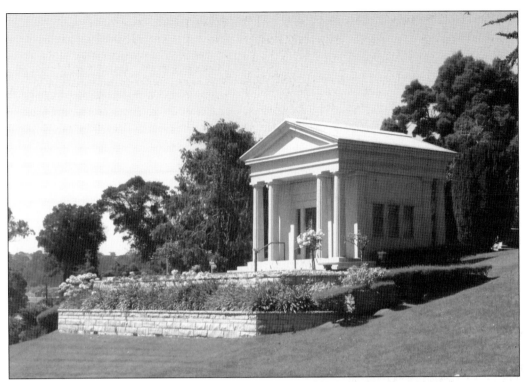

This family chapel at Cypress Lawn Cemetery reportedly cost $5 million to build. According to Andrew Canepa at the Italian Cemetery, most people die in the winter months; perhaps because the nights are longer at that time of the year. Though the number of funerals is down in Colma, cemetery business is still good. (Courtesy of the author.)

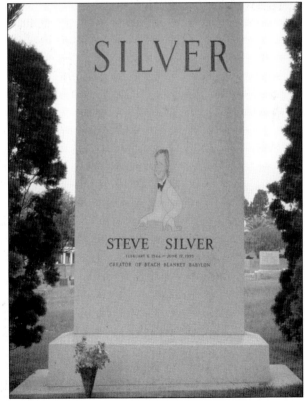

This is Steve Silver's monument at Cypress Lawn Cemetery. Steve (1944–1995) was the creator of musical review "Beach Blanket Babylon." Eulio Fontana created this monument. (Courtesy of the author.)

Across America, People are Discovering Something Wonderful. Their Heritage.

Arcadia Publishing is the leading local history publisher in the United States. With more than 3,000 titles in print and hundreds of new titles released every year, Arcadia has extensive specialized experience chronicling the history of communities and celebrating America's hidden stories, bringing to life the people, places, and events from the past. To discover the history of other communities across the nation, please visit:

www.arcadiapublishing.com

Customized search tools allow you to find regional history books about the town where you grew up, the cities where your friends and family live, the town where your parents met, or even that retirement spot you've been dreaming about.